IMAGES
of America

MARION
COUNTY

IMAGES
of America

MARION
COUNTY

Thomas J. Koon

ARCADIA

Published by Arcadia Publishing,
an imprint of Tempus Publishing, Inc.
2 Cumberland Street
Charleston, SC 29401

Printed in Great Britain.

Library of Congress Catalog Card Number: 2001087921

For all general information contact Arcadia Publishing at:
Telephone 843-853-2070
Fax 843-853-0044
E-Mail sales@arcadiapublishing.com

For customer service and orders:
Toll-Free 1-888-313-2665

Visit us on the internet at http://www.arcadiapublishing.com

CONTENTS

Acknowledgments 6

Introduction 7

1. Early Residents 9

2. Early Industry 27

3. Businesses 43

4. Education 61

5. Landmarks 73

6. Community Leaders 85

7. Parades, Gatherings, Reunions, and Parks 95

8. Communities 113

9. Miscellaneous 123

ACKNOWLEDGMENTS

The photographs and illustrations that appear in *Images of America: Marion County* have been secured from numerous sources. Many have been taken from the author's own collection of pictures that have been accumulated over a number of years. Some came from photographs taken by the author's mother many, many years ago. Others were snapped by his late brother-in-law John F. Shotts, an avid camera buff.

Most of the images contained herein came from original prints; others are taken from copies made from original prints. A large number of pictures were donated to the Marion County Historical Society Museum in Fairmont, West Virginia, from the estate of the late Jack "Hardrock" Bunner, and we were able to copy several of these for inclusion in the book. Copies were also made of other pictures available at the museum, some of which were donated by various people. Some copies were made of photographs currently held at the West Augusta Historical Society Museum in Mannington, West Virginia.

Several individuals permitted copies to be made from pictures in their possession. Others graciously offered prints in their possession to be copied but, unfortunately, most of these were reprints of original photographs and were not of the proper quality to be successfully reproduced. We hope that all these people who contributed, or tried to contribute, to the large number of prints in this book will be pleased with the results in this salute to the County of Marion (formerly of Virginia, now of West Virginia.)

I most certainly want to thank my wife, Mary, for generously allowing me to strew pictures all over our dining room table while I tried to choose, and properly identify, the best pictures for this book. My editor, Laura Daniels, was a great help and I do thank her.

INTRODUCTION

The area that is now Marion County was once only a small portion of the original vast Augusta County, Virginia. After several territorial changes reduced the size of Augusta County, what is now Marion County emerged in 1779–1780 as a part of a new Monongalia County, Virginia. Then, in 1784, part of what is now Marion County was assigned to the newly formed Harrison County. In the meantime, the area was slowly being settled, and the Native American tribes who had held previous claim to this formerly uncharted wilderness were slowly being pushed farther and farther westward.

In 1787, Boaz Fleming led a party of relatives and friends from Milford, Delaware, across the mountains to the area that is now Fairmont, West Virginia. The group settled there but later found that part of them resided in Monongalia County, Virginia, and the others lived in Harrison County, Virginia. Boaz and his brothers finally came to resent the fact that they had to travel to either Morgantown or Clarksburg, the respective county seats, in order to pay taxes or transact legal business. Boaz eventually decided that he would found a new county to eliminate all the travel and lost time and started a petition to have a new county created. He suggested the name "Madison" in honor of then President James Madison and felt fairly confident of success since he had considerable political "pull" available through his cousin Dolley Madison, the wife of President Madison.

There was, however, only one town in existence within the boundaries of the proposed county, and that town, Milford (now Rivesville), refused the honor of being the county seat. Without a county seat available, the idea of a new county had to be abandoned. Fleming tried again in the early 1820s after he had founded a town named Middletown on part of his land. He had created this town for the sole purpose of being the county seat of the proposed new county. But Madison was no longer president and Fleming's chief political ally, John G. Jackson, got sick and died suddenly. Without strong political support, Fleming could not gather the momentum necessary to secure a legislative act to create the desired county. Thus, his second attempt failed, and Fleming died without his desired county seat (though he had founded the town that would eventually become the county seat of a new county). Others would have to complete the work for him.

By 1840, support had increased for the idea of having a new county created out of parts of Monongalia and Harrison Counties and plans were carefully laid out to have this action completed. By the end of 1841 all seemed ready. William S. Morgan, a delegate from Monongalia County, introduced a bill on January 6, 1842 in the House of Delegates to create a new county from parts of Monongalia and Harrison Counties. The bill passed the lower house by a vote of 94 to 26; however, it received considerable opposition in the Senate. Through good maneuvering by Sen. William J. Willey, who represented the local district, enough support was developed to get the bill passed by the Senate.

The Act of the General Assembly of Virginia creating the new county was adopted on January 14, 1842. The name chosen, however, was Marion after Revolutionary War hero Francis Marion. Middletown was chosen as the county seat since Milford was still unwilling to assume the responsibility of being the center for the county's legal business. Descendants and relatives of Boaz Fleming were pleased that Boaz's dream had finally been fulfilled even though it had not happened in his lifetime.

Residents soon discovered that there was another Virginia town named Middletown. This one was just south of Winchester, Virginia, and having two towns with the same name caused a certain amount of confusion—especially since one was a county seat. Thus, in 1843, the local name was changed to Fairmont (Fair Mount) to avoid confusion.

Marion County has produced quite a number of political leaders since its creation. Three West Virginia governors were Marion County residents: Aretas Brooks Fleming, Ephraim F. Morgan, and Matthew M. Neely. Three Marion County natives served as state treasurer and two were elected as secretary of state. Robert Mollohan represented the county in the U.S. House of Representatives, and his son Alan continues to do the same. Several individuals served as U.S. senators. And, going back to its early beginnings, Marion County was the home of the man called the "Father of West Virginia"—Francis H. Pierpont. Pierpont was instrumental in helping establish the "Restored Government of Virginia" and then serving as its governor until the close of the Civil War and the re-establishment of a loyal Virginia government in Richmond. Pierpont completed that term of office and then returned to Fairmont. He was never governor of West Virginia but is often referred to, in error, as the first governor of West Virginia.

Another man who deserves much credit for the formation of West Virginia was the Farmington native Waitman T. Willey, who was the first U.S. senator from West Virginia. He also has the unique distinction of having served two states as U.S senator since he was chosen as one of the senators from the Restored Government of Virginia and then as a senator from West Virginia when it was established as a state.

Marion County has been the home of several coal and oil barons who made fabulous fortunes during the boom times but lost much of their wealth when the Depression hit the energy markets. Prominent among these figures were the Watsons, the Hutchinsons, and several others. The county has also been the scene of several terrible mining disasters, such as the 1907 explosion at Monongah and the Farmington No. 9 catastrophe. Much wealth has been wrested from beneath the surface in Marion County but the price in human life and suffering has also been great.

One
EARLY RESIDENTS

The identity of the first people to inhabit the area that is now Marion County remains a great mystery. Some tantalizing evidence remains to suggest that this territory was home for a number of years to members of the "Mound Builders" culture who seemingly possessed a high degree of civilization but eventually disappeared from the scene. Were they entirely destroyed by a warlike tribe or were they the victims of an epidemic that wiped out all their members? Archaeologists will continue to debate that question for years to come and probably never secure a definite answer.

Early settlers have left many stories that have been passed down through family history about a number of small burial mounds encountered by farmers as they tilled the ground to secure the crops needed to feed their families. Most of those pioneers had no interest in preserving historical artifacts; their interest was in growing food for survival in the harsh environment. So human bones and ancient tools or weapons, when disinterred from the mounds, were regarded with mild curiosity and then tossed aside as of no value. The mounds were plowed under and mostly forgotten.

Ancient weapons, tools, and artifacts continue to be found by local searchers and prove the existence of earlier inhabitants in this area. These may have been the descendants of the remnants of the Mound Builders civilization or they may have been an entirely different race. By the time the first European colonists arrived in this area, there appeared to be no permanent residents remaining although many Native American tribes had established hunting and fishing camps throughout the region.

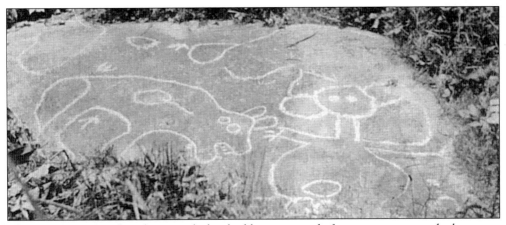

These carvings were found on a rock that had been exposed after a storm uprooted a large tree north of Rivesville, West Virginia. It is unknown how old these carvings may be or to what race the artist belonged. They do prove the existence of an earlier race in this region. (Courtesy of Marjorie Hood Jones.)

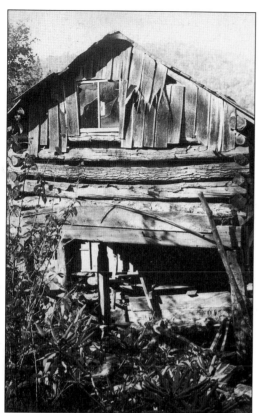

The 1941 photograph at left shows a local log cabin probably built in the early 1800s. The boards on the gable end were installed at some later time, as was the window. A small cabin such as this one was probably home to a large family when it was first built. The pioneer was faced with many decisions when it came to survival. First, he had to erect some sort of temporary shelter for his family and livestock, if he possessed any, and then make provisions for the safety and well being of all.

The cabin in the image at left was a definite improvement over the settler's first rude shelter. After enough land had been cleared and burned off to permit considerable crop planting, the settler could take time to "dress" logs for the construction of a house with two stories and a wooden floor made with puncheons (logs that had been planed on one side with an adz or a broad ax). The fine cabin below stood near Idamay for many years. Many improvements were made to it during the late 1800s and early 1900s.

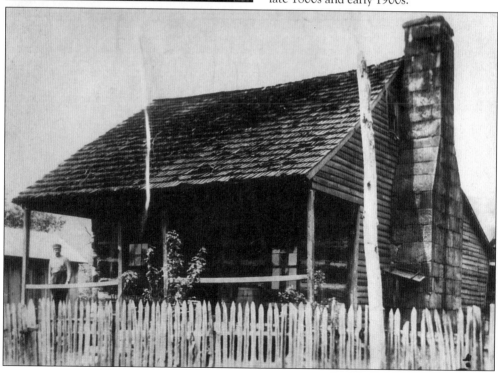

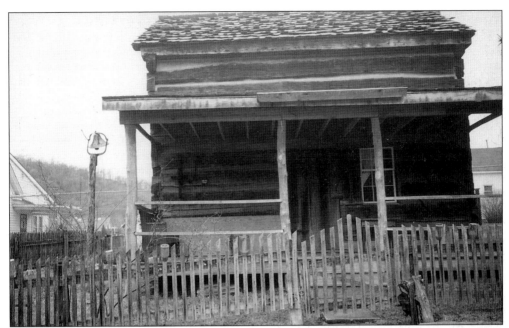

This log cabin is located at the West Augusta Historical Society Museum in Mannington, West Virginia. Considerable improvements have been made to the structure since it was first built. The early cabin certainly had no glass window—probably only an open aperture to allow light to enter or one covered with, if obtainable, oil-soaked paper. A mixture of moss and clay was normally used to fill the spaces between logs. Wood chips were often stuffed into larger cracks before the moss-clay mixture was applied.

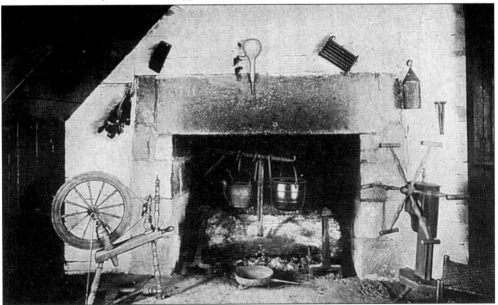

The early settler usually started out with very little in the way of utensils, tools, or household items. Often slabs of wood served as serving and eating plates, and utensils were carved out of pieces of wood. The items shown at the fireplace in the S.L. Watson farmhouse were undoubtedly accumulated over a long number of years, mostly through barter or purchase.

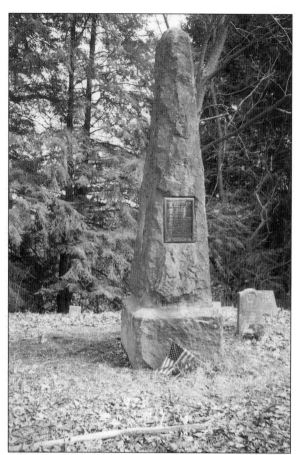

This stone was erected in the Cochran Cemetery near Thoburn in honor of Nathaniel Cochran, an early pioneer and settler. He and his wife were the initial settlers in Thoburn and West Monongah. As a young man, Cochran was wounded and captured by Native Americans at the time Capt. James Booth was killed; he was eventually traded to the British. Cochran remained in British captivity at Detroit, then at Quebec, until the close of the Revolutionary War.

A monument was erected in honor of David Morgan in Rivesville, West Virginia. Morgan, a famous frontier fighter and scout, was one of the leaders of the early settlers. He is probably most famous for his successful struggle with two Native Americans who were attempting to kill his two children. When Morgan alerted his children and then diverted the men, they engaged him in an epic struggle to the death.

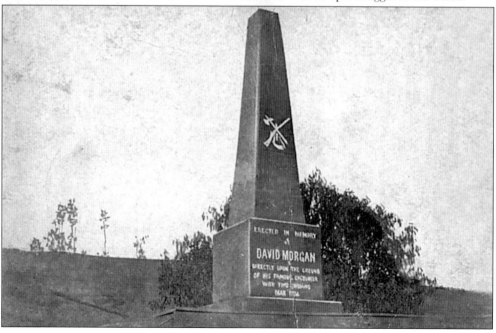

Capt. James Booth was a famous early settler and frontier fighter who was killed near this location on June 16, 1778 by a group of marauding Shawnee warriors while he and Nathaniel Cochran were working in a cornfield. Booth was well educated for his time and was an acknowledged leader of the settlers. Boothsville and Booth's Creek are both named after him, and this monument was erected near Booth's Creek in his honor.

Pictured below is an arrangement of cooking utensils and holders at the fireplace in the cabin of a well-to-do settler. Although the average settler did not have as fine a fireplace as this one and most certainly would not have had all this equipment, cooking was done in much the same way. The arms would swing back and forth and permit the cooking pot to be directly over the flame for fast cooking or held back to a desired distance for varying degrees of heat.

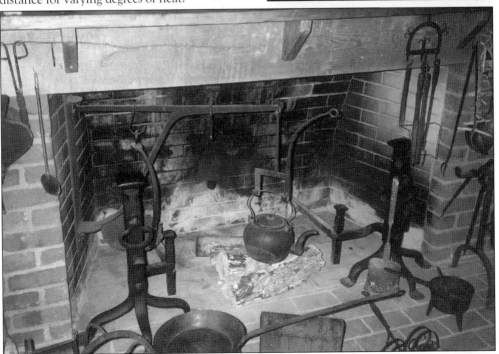

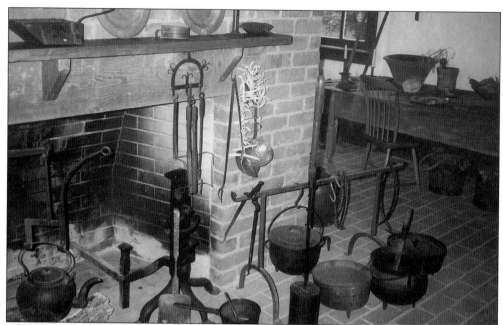

The various cooking utensils and equipment seen here were used by early residents of Marion County and the surrounding areas. In spite of the many pots available here, no one could cook without encountering a lot of soot.

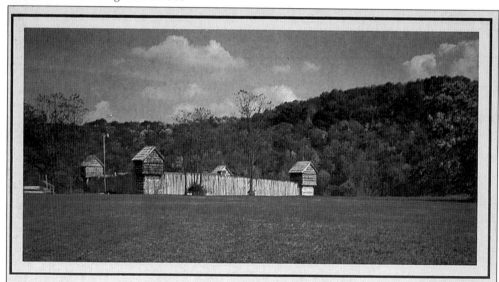

Prickett's Fort, West Virginia

At times that Native Americans were reported to be in the area, settlers would pack together what valuables they were able to carry and rush to a nearby fort where they would stay until the threat of an attack was over. Prickett's Fort is the most famous of the frontier forts in what is now Marion County. This fort was constructed in 1774 and then reconstructed some 200 years later as part of a national park.

Another well-known fort in the county was Koon's (Coon's) Fort near Kilarm. Although not as large as Prickett's Fort, this fort had troops garrisoned there and served as a place of refuge for many of the settlers in the area. No remnants of the fort remain.

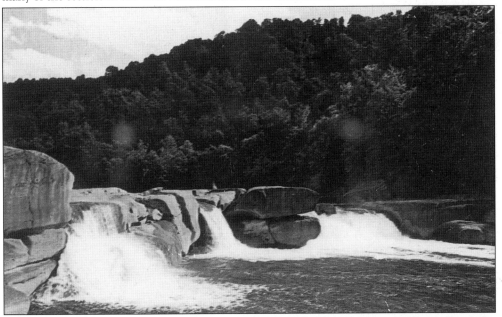

Terrific force could be generated by water cascading down a steep fall. At Valley Falls on the Tygart Valley River the quick drop in elevation certainly produced considerable power. A large mill was built there in the early days and a sizeable community began to develop. Most of it was abandoned after a disastrous fire.

Settlers liked to build near water. Transportation was made easier due to the nearby stream that could be navigated by canoe or boat, and the water could provide power to drive a paddle wheel to grind grain. However, the danger was that all could be destroyed by a sudden flood in those days before flood control measures. Here, a late winter flood threatens to overflow riverbanks and wash away any structures erected by a settler.

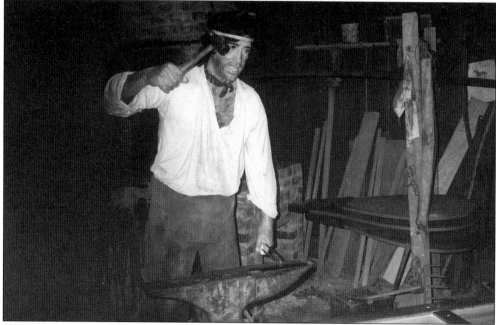

A very essential member of any frontier community was the blacksmith. If you needed tools made or repaired, you went to the blacksmith. If you needed weapons for defense or to seek out game for food, you went to the blacksmith.

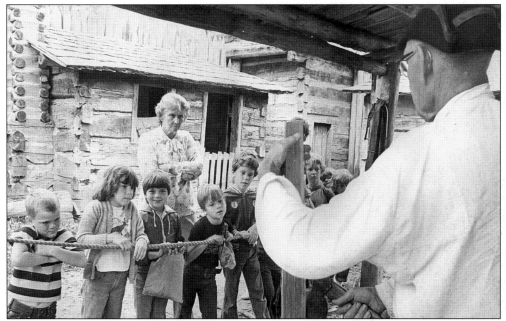

Most settlers in early times managed to make most of their home supplies by hand or to trade for them. As people began to live closer together and communities were formed, some people began to specialize—they each had skills their neighbor might not possess. Here we have a volunteer at Prickett's Fort making roof shingles to demonstrate his unique skills. He has an appreciative audience watching his every move.

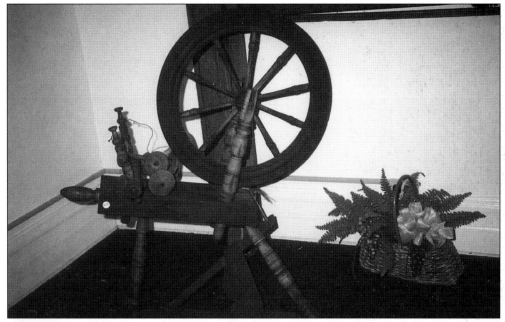

An essential tool for every frontier woman was the spinning wheel. Each frontier mother taught her daughter the proper method to operate a spinning wheel almost before she gave her instruction in much else. A lady might do well without knowing how to read or write but she could not exist without knowing how to spin.

17

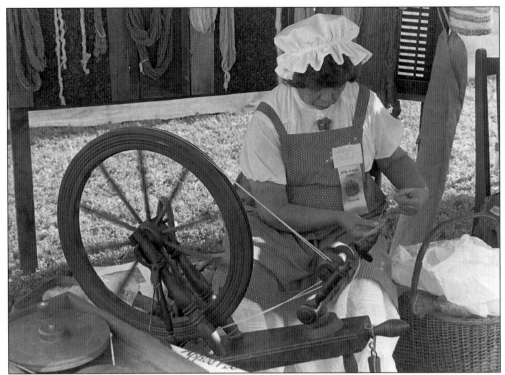

Here, a volunteer at Prickett's Fort demonstrates the correct way to operate a spinning wheel. She will later demonstrate how to weave cloth and how to make garments for herself, her husband, and her entire family.

Volunteers at Prickett's Fort take time off from their chores of making quilts and perform a dance to celebrate their work. They appear to be proficient both in making quilts and in the art of intricate dances.

As more and more people moved into western Virginia, representatives from this area began to be elected to the General Assembly of the Commonwealth of Virginia. It was necessary for them to go to Richmond to attend the sessions. Since the trip from the far west was somewhat perilous, the legislators would band together to make the long trip in safety.

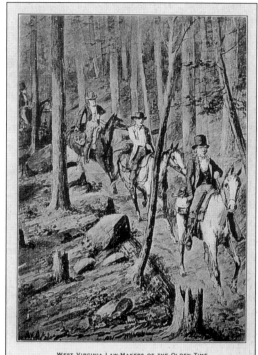

WEST VIRGINIA LAW-MAKERS OF THE OLDEN TIME

MEMBERS OF THE GENERAL ASSEMBLY OF THE COMMONWEALTH ON THEIR JOURNEY OVER THE ALLEGHANIES AND THE BLUE RIDGE TO ATTEND A SESSION OF THAT BODY AT RICHMOND. TIME, ABOUT 1820. (TAKEN FROM ARCHIVES AND HISTORY OF WEST VIRGINIA.)

In the early days, pioneers carried supplies in packs on their backs. When they managed to obtain horses, they devised packsaddles so that the horse could carry a sizeable load. In due time, the horse was hitched to a sled and was thus able to handle larger loads. This sled undoubtedly was used both for freight and passengers.

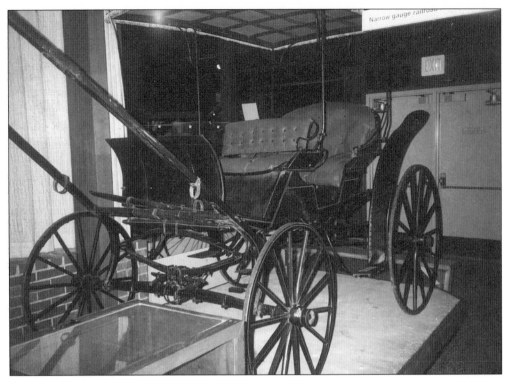

This passenger carriage looks like it was intended for the rider's comfort judging by the shiny padding on the seats. It was "state of the art" for that time.

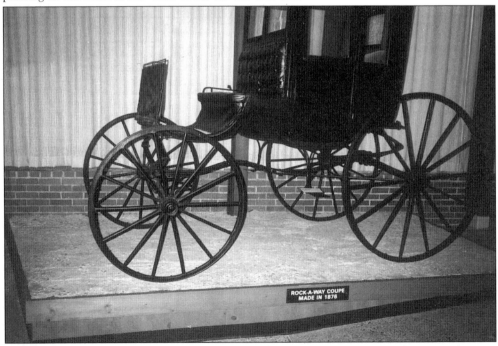

This passenger coupe ensured great privacy and protection from bad weather; however, the poor driver would have to endure rain or snow in inclement weather.

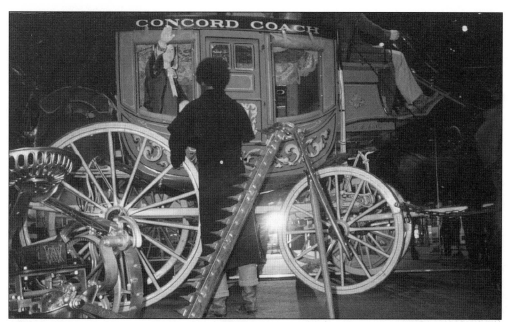

The Concord Coach, pictured here, became the desired vehicle when one traveled via stagecoach. The passengers were protected from the weather but the driver was not.

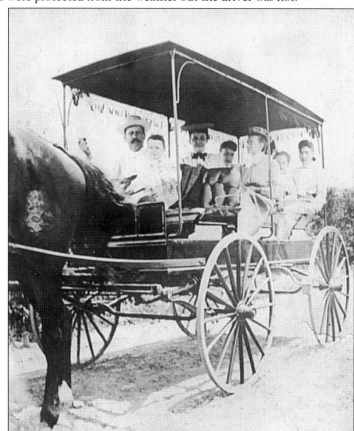

If you had a large family and wanted to go for a drive, or if you wanted to operate a rental vehicle, this three-seat carriage would be ideal—at least in good weather. No side curtains were provided but there was protection from the sun above.

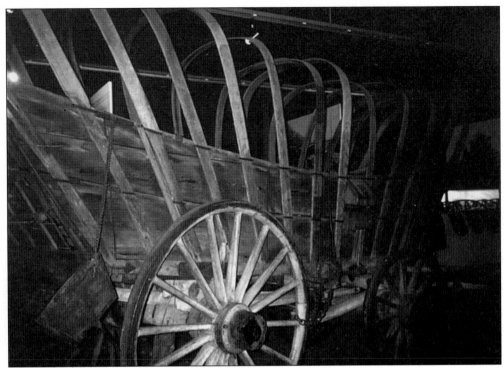

In this view of the construction of a Conestoga wagon, note the wooden ribs that support the canvas cover. The wagon was built to last a long time and to carry heavy loads.

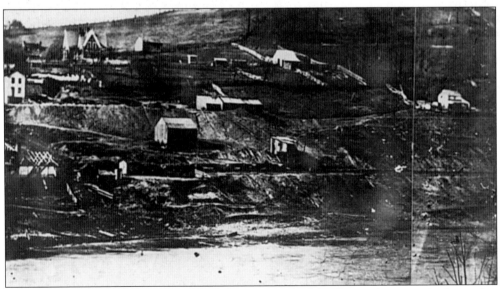

Near the center of this photograph is the front opening of the first coal mine to be located in Fairmont. It was situated on Washington Street on land owned by Francis H. Pierpont. Coal was loaded into a chute and slid down to railroad cars below.

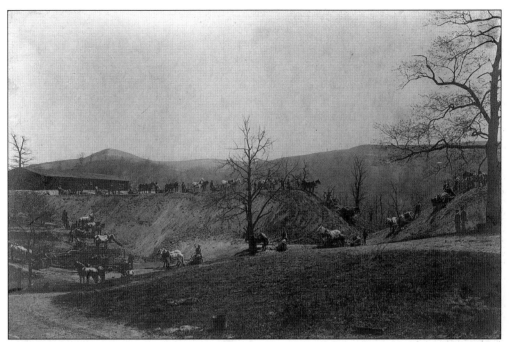

In this 1901 view, heavy construction is going on in the vicinity of Twelfth Street in Fairmont, where the Fairmont Development Company had begun to develop the South Side. The land was certainly not flat, and many teams of horses were required to level off hills and fill in valleys. Several glass plants would occupy the area later, including the well-known Monongah Glass Company. (Courtesy of John S. Hamilton.)

Horsepower was in great demand and the horses, as well as drivers, did their best on the construction work at hand. In a few months this area would look quite different. It is amazing to consider what huge amounts of earth were moved by the relatively primitive equipment of that day.

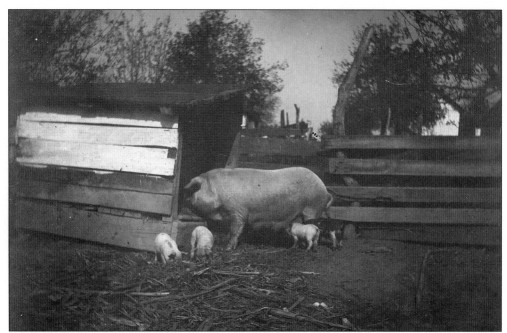

In those early days nearly every rural farm had livestock, and a sow and piglets, cows and calves were a common sight. Even early residents of towns kept livestock since there were no laws forbidding that.

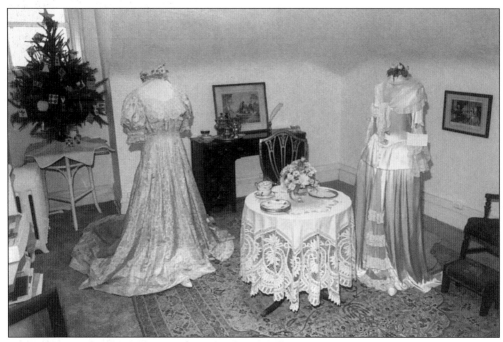

Although early settlers did not possess considerable wealth, there were always those who had been able to acquire material things and display them. Beautiful furniture and beautiful dress tended to denote wealth and position. These gowns on display at the Marion County Historical Society Museum denote that.

Large families were not uncommon in earlier days. In this photograph, the young ladies wearing black stockings are sisters; those wearing white stockings are cousins.

Much of the early farm labor was performed by hand. All grain was cut with the use of a grain cradle such as this one displayed on the wall of the West Augusta Museum in Mannington. Although the cradle appears primitive today, it was a great laborsaving device and an improvement on the hand sickle that had previously been used to cut down the stalks of grain.

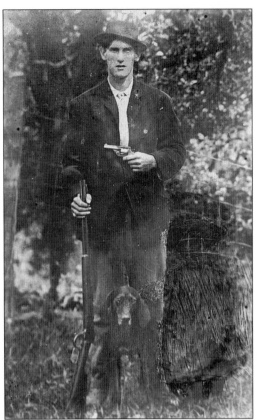

Early settlers were self-reliant and often had little use for a judge or an officer of the law. This man appears ready to take on any and all comers. He would probably hold his own in any contest that required a shotgun, a pistol, a dog, or any hand-to-hand scuffle. It is very likely that he has a knife in a sheath on his belt.

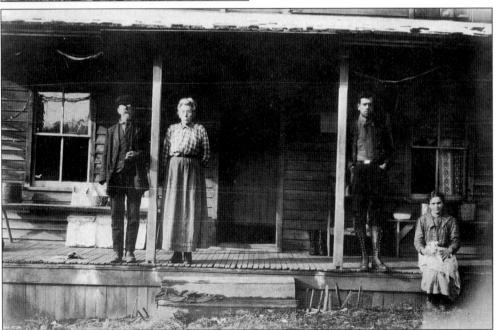

Two generations of an early family pose for this picture on their front porch. The house was probably new when the couple on the left was married.

Two
EARLY INDUSTRY

Early industry in Marion County centered on timbering due to the vast forests throughout the region. Trees were felled, hauled to nearby streams, and made into rafts that were floated downstream to waiting markets in Pennsylvania. The large amount of timber available brought about the development of tanneries. The many streams also provided the needed water and the needed drop in elevation to operate grain mills and saw mills. Farming began to become a large industry as great fields of grain were grown and harvested so that the grain mills could provide the desired flour and meal.

The coming of the railroad in 1852 provided easy access to markets to the east and later a connection to the Ohio River area and Pittsburgh. Coal began to grow in importance. By 1890 a great boom occurred in the coal, oil, and natural gas industries, which began to take center stage in the region. Many workers found employment at glass plants, including the Monongah Glass Company and Owens-Illinois Glass. By 1940 Westinghouse had come to Fairmont; much earlier, Bowers Pottery put Mannington on the map.

Later in the 1900s, the continued need for coal and other energy sources kept the economy of the region booming, but, little by little, the once-plentiful energy sources began to disappear.

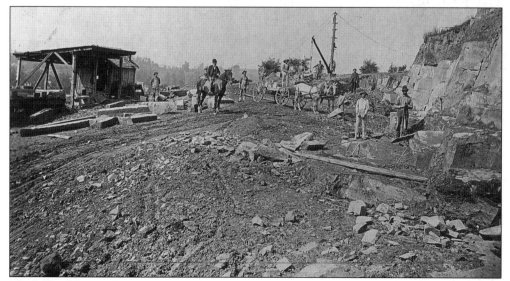

The J. Fay Watson Stone Quarry at Fairmont appears in this c. 1901 photograph. Much of the early road ballast came from this quarry.

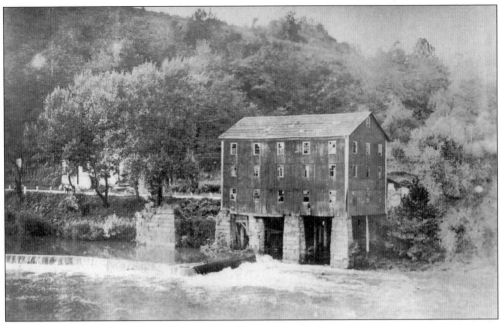

The old Worthington mill served the local farmers faithfully, and a number of similar mills remained in operation throughout the county for many years.

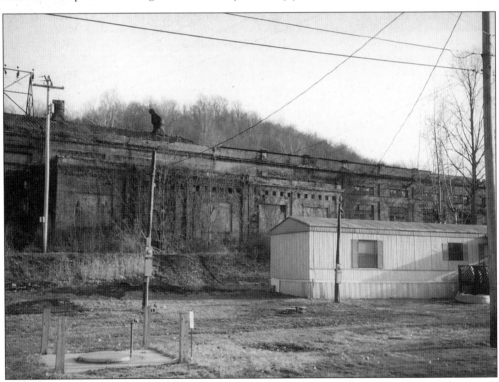

The Fischer Foundry near Hutchinson is no longer in operation and is a safety hazard that needs to be torn down. It was once a power station for the Monongahela Power Company in the early part of the last century and was replaced by the Rivesville Power Plant prior to 1920.

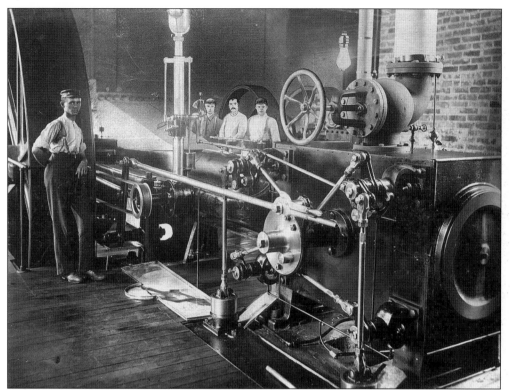

This *c.* 1901 image shows the interior of the powerhouse of the Fairmont and Clarksburg Electric Street Railroad Company. Electricity was brought to Fairmont about 1900 in order to run the electric streetcars.

Teams of horses are seen here harnessed and ready to pull mowing machines for a day's hard work. Today, all this work is done by tractor.

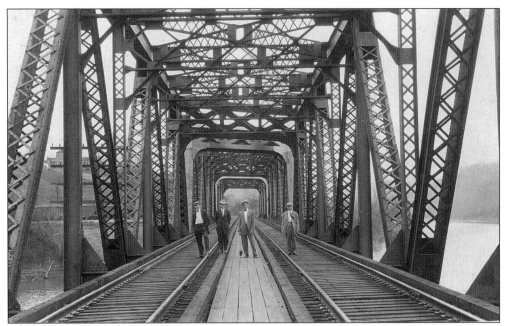

For years railroad trains thundered through the county hauling passengers and pulling gondolas loaded with coal. First steam locomotives, with their mournful whistles, pulled the loads. Then diesel took over. Finally the markets began to dry up and the need for the trains disappeared. Most of the train tracks are now dismantled. Pictured here is a railroad bridge near Fairmont.

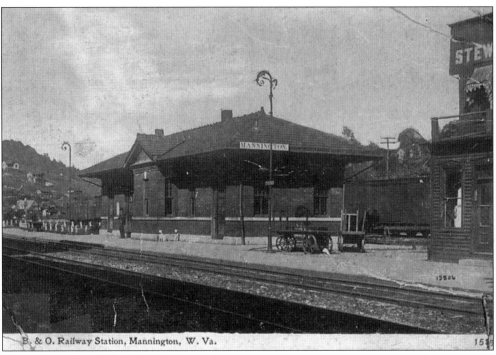

The Baltimore and Ohio (B&O) Railroad Station at Mannington was once a bustling spot with passengers eager to board the train and freight wagons waiting to be unloaded.

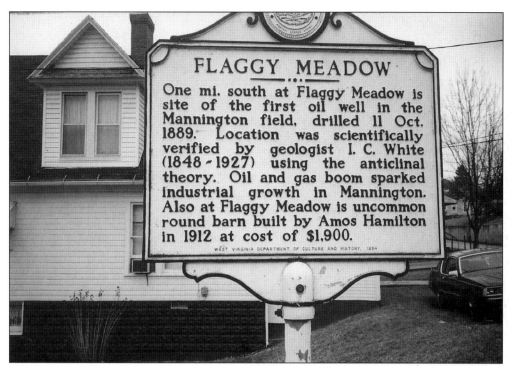

The first oil well in the Mannington field was drilled at Flaggy Meadow and sparked the great oil boom that helped create wealthy oil barons in Mannington, Fairview, and many other spots. The quiet little towns would be quiet no longer.

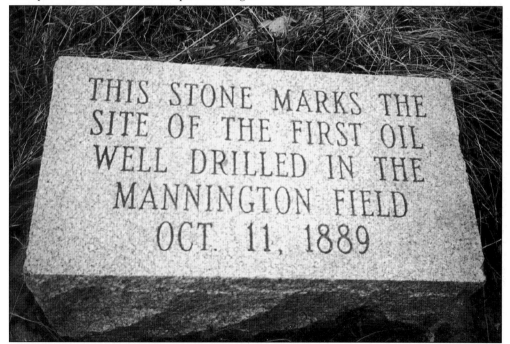

On October 11, 1889, the first oil well was drilled in the Mannington oil field. The oil boom began and the race was on to discover new producing wells.

This working model of an oil well derrick at the West Augusta Museum in Mannington makes an excellent showpiece for guided tours.

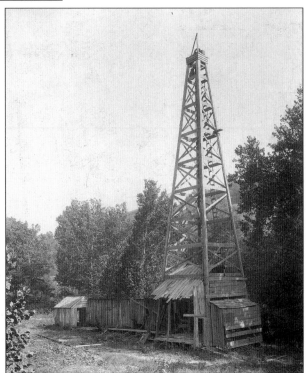

Belonging to the Fairmont & Grafton Gas Company, this natural gas well derrick was one of many in the Mannington area around 1900.

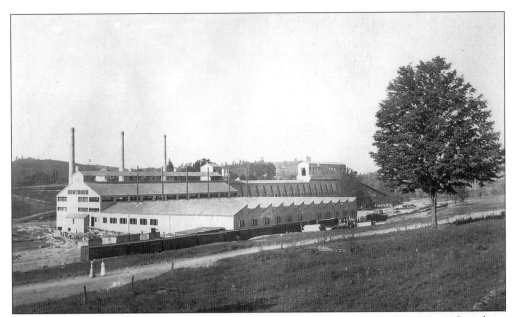

Pictured above is a view of the early Owens-Illinois Glass Company at its site near Speedway Avenue in Fairmont. The plant was just getting started and there are few homes in the vicinity. In a few years all this would change and homes and businesses would abound. (Courtesy of the estate of Bill Myers.)

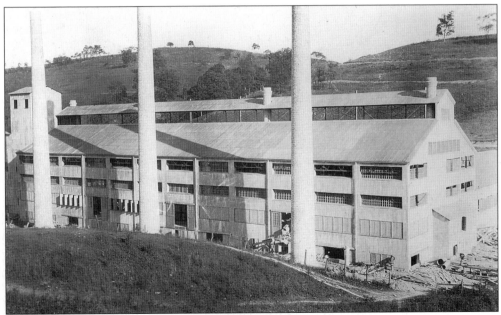

In another view of the new Owens-Illinois plant, construction debris has not been cleaned up yet and the surrounding area looks almost desolate. (Courtesy of the estate of Bill Myers.)

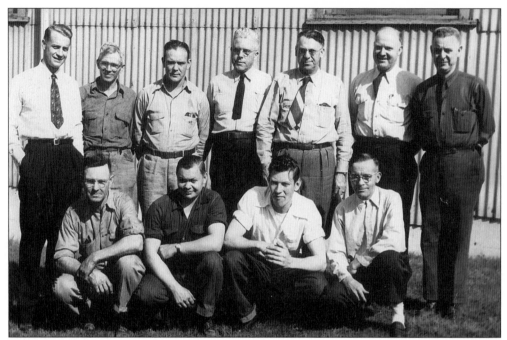

Pictured above are the maintenance department supervisors and safety committee from Owens-Illinois Glass Company. The plant had now gotten a good start and production was going well. The plant was creating employment for many.

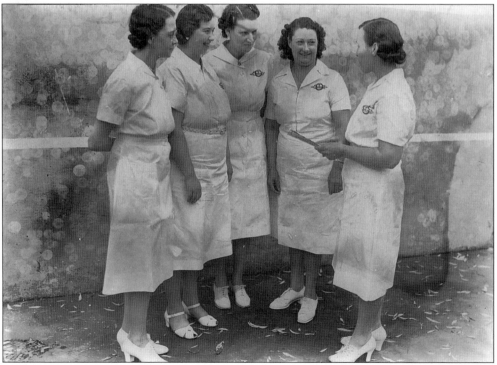

A group of nurses from Owens-Illinois Glass stop work long enough to discuss the problems of the day and also to identify various ailments suffered by patients.

Here, ladies examine the framework on construction being done for the new Domestic Coke plant in the East Fairmont area. The plant operated successfully for many years but was finally taken over by Sharon Steel and later purchased by others. The plant is no longer in operation and has been the subject of years of litigation due to possible toxic contamination.

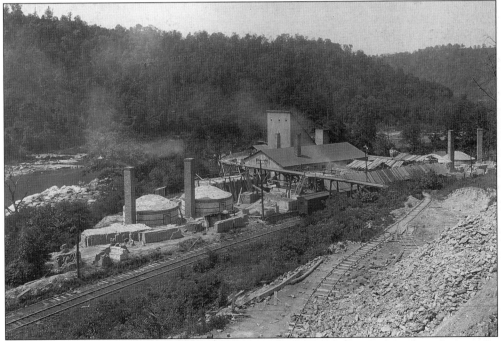

The Hammond Fire Brick Company, located in Hammond, enjoyed many years of successful operation and supplied bricks to many projects throughout the Northeast. But market demands eventually changed and other building products captured much of the business that Hammond had once enjoyed. Finally, a disastrous fire caused the plant to close.

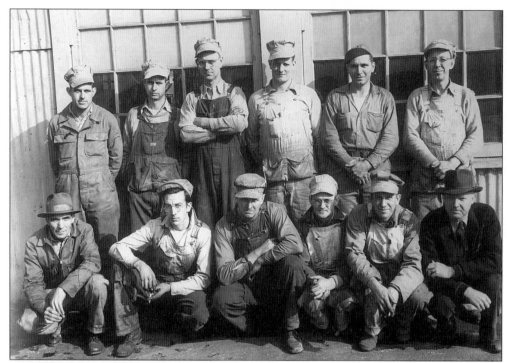

When this picture of the carpenter crew from Owens-Illinois Glass Company was taken on December 31, 1946, the crew had achieved a total of 1,462 accident-free days. A truly remarkable achievement!

This old railroad freight station in East Fairmont was operated for some time as a Railway Express Agency after the freight station closed. The location is now occupied by an automobile parts store.

The railroad trestle at Helen's Run was judged unsafe and unnecessary once the railroad there had been dismantled, and the trestle was torn down for safety's sake. Soon, most vestiges of the once-great railway system enjoyed by residents of Marion County will have disappeared. Many other trestles have been torn down and the tracks have been destroyed. Only a few railroad tracks remain.

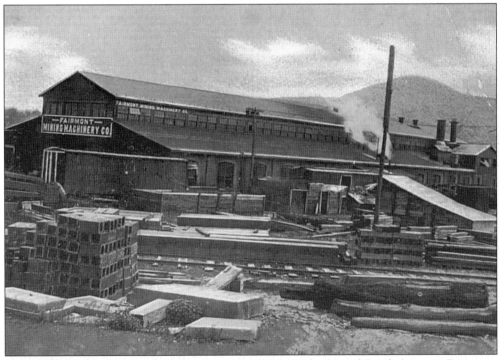

Pictured here is the Fairmont Mining Machinery plant at the foot of Tenth Street in Fairmont. This company enjoyed great success in the mining machinery business, but its success was closely tied to the success and failure of coal mining companies. As the coal mines closed, Fairmont Mining Machinery's business declined.

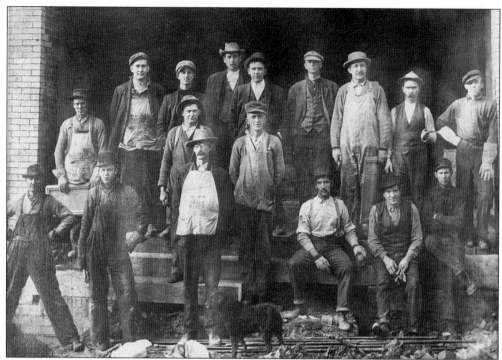

A group of plant workers pose for a photograph after a hard shift at the plant. Taken apparently before the days of safety equipment, this picture shows the considerable variety of work clothes and hats.

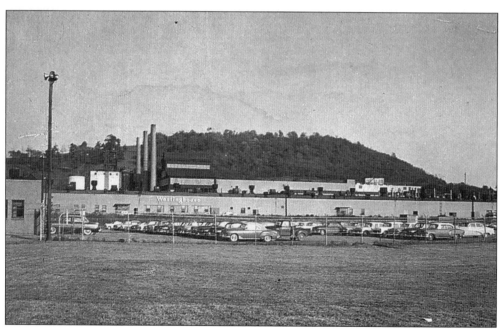

At the time this late 1940s photograph was taken, the new Westinghouse Electric plant outside Fairmont employed 1,475 people and was the world's largest glass-fluorescent plant. Having undergone several work revisions, the plant now houses Phillips Lighting.

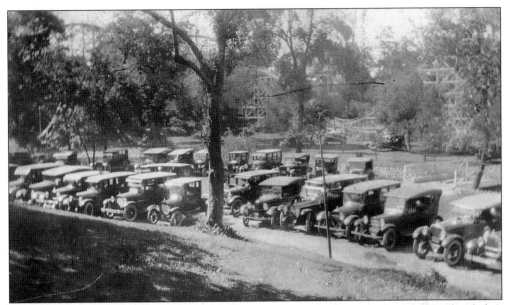

Once plant workers had worked long enough to create a "nest egg," most of them decided to spend it on an automobile in order to get to work more easily. From the looks of the cars in this parking area, it appears that many "nest eggs" were spent for that purpose.

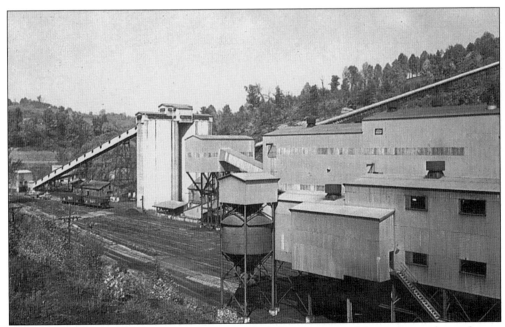

The preparation plant of Jameson Coal and Coke Company Mine #9 was located near Farmington. Later, the mine was sold to Consolidation Coal Company and renamed Consul #9. A tragic mine explosion happened here; many miners were killed and the mine was sealed.

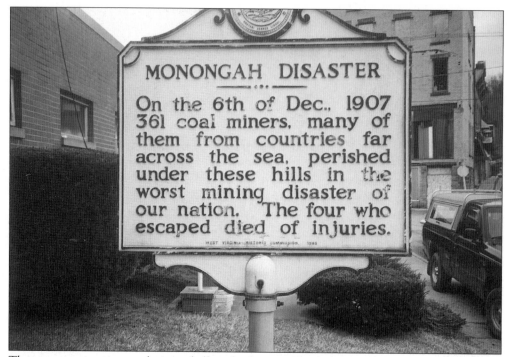

MONONGAH DISASTER

On the 6th of Dec., 1907 361 coal miners, many of them from countries far across the sea, perished under these hills in the worst mining disaster of our nation. The four who escaped died of injuries.

The most tragic mine explosion of all took place on December 6, 1907 in Monongah when some 361 miners perished. Although the official count listed 361 fatalities, many people believe the correct count was far higher—some putting the toll at over 500.

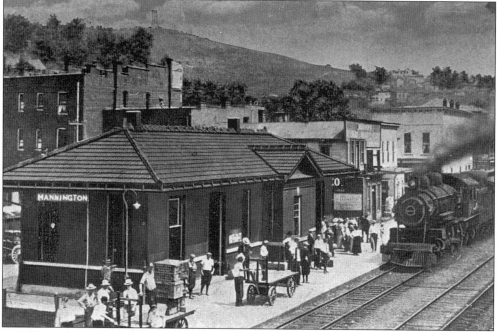

A B&O train pulls into the Mannington train depot from the east. Several people appear ready to board the train, and freight carts are ready both to load and to unload baggage and freight. Mannington remained an important train center.

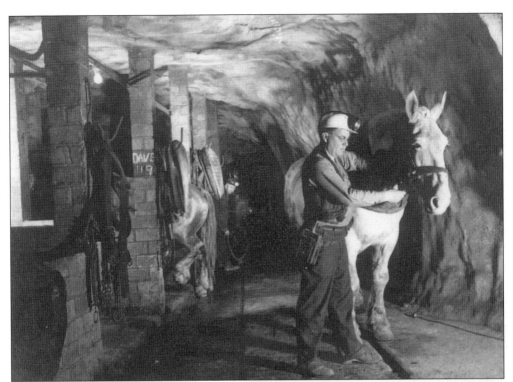

Horses were used to haul cars of coal even after the advent of electric haulage motors, and a bond of affection existed between many miners and the horses with which they worked. Pictured here is a miner with a horse in an underground horse stable at a Barracksville mine. (Courtesy of Ann Neptune.)

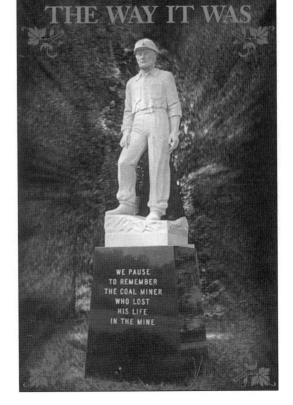

THE WAY IT WAS

WE PAUSE
TO REMEMBER
THE COAL MINER
WHO LOST
HIS LIFE
IN THE MINE

A monument was erected in honor of the coal miners who lost their lives to accidents or explosions in the local coal mines. This statue is located at Mary Lou Retton Park between Monongah and Fairmont.

41

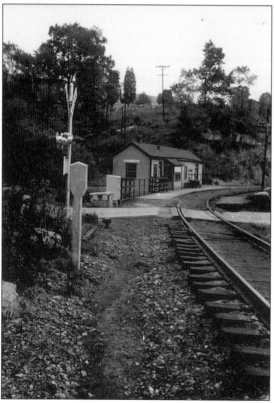

Pictured above are Barnesville Shaft and Mine personnel at the Consol Mine at Bellview. A very productive mine during the years of its operation, Barnesville was often used by Consolidation Coal Company as a training area for their prospective mine superintendents. The mine has been closed for many years and no trace of it remains. (Courtesy of Mrs. Arthur Stewart.)

This old train depot near Barrackville is no longer in existence.

Three
BUSINESSES

In the early days, each settler faced the responsibility of providing all the necessities of life for himself and his family. But, as more and more people moved in and communities were founded, this had to change. Diversity took over and the individual needed to barter for or purchase the items he could not produce himself. Trading posts were started and these developed into stores.

The area was fairly well developed by the time Marion County was established in 1842, but it was still quite rural. The coming of the railroad through the county in 1852 opened up the area, but it was not until about 1890 that the entire county's economy exploded as a coal boom was quickly followed by an oil boom and then by a natural gas boom. Millions of dollars were made and quickly spent. Stores of all kinds were established, banks were founded, and hotels proliferated as more people came in to "share the wealth." Laborers were imported to work the mines and the oil and gas fields.

Eventually the booms died out and depressions struck the county just as they did elsewhere. Few, if any, of the original businesses remain but they were replaced by others. Many of the early banks are no longer here but others survive. Most of the early hotels are gone but a few motels have replaced them. The economy is struggling but it is surviving.

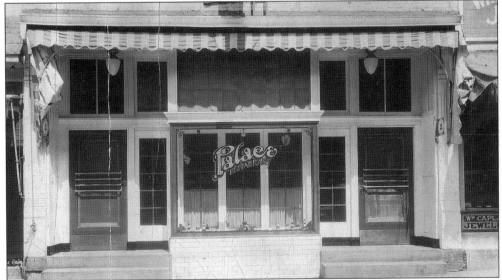

The famous Palace Restaurant in downtown Fairmont flourished during the glory days of the county's economy. It was the favorite spot for local residents and visitors to congregate and discuss the economy or a recent ball game while enjoying a cup of coffee and a pecan roll.

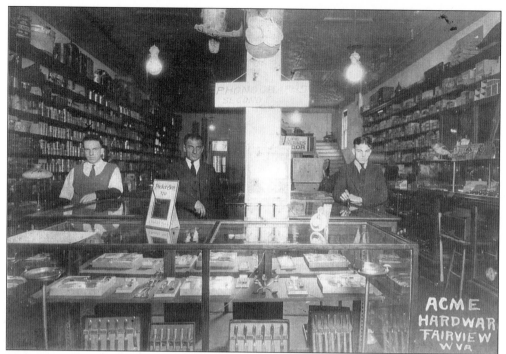

The Acme Hardware Store in Fairview prided itself in maintaining a full line of hardware supplies as well as other needed goods. If the store did not stock a needed item, a clerk would attempt to find out where you might find that item. "Courtesy" was the password.

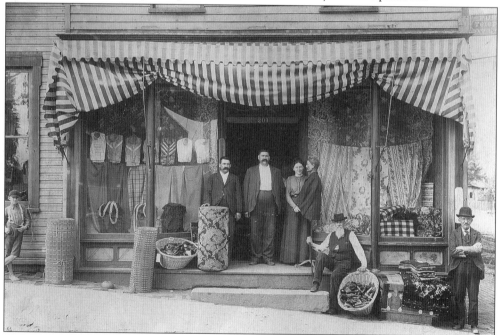

J.S. Pople's Department Store, located at the corner of Market and Merchant Streets in Palatine (East Fairmont), was a family-oriented business established in 1877 and was soon a popular spot to buy household items, clothing, and carpets.

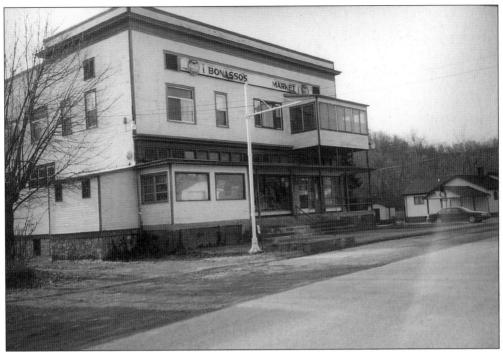

Small markets, usually family operated, such as this one near Carolina, served the community well. Bonasso's Market provided most of the residents' food needs and carried many of the other items needed for everyday living.

Residents in smaller communities needed supplies and food items just as much as people living in larger towns. Local stores helped to satisfy these needs without forcing customers to drive several miles to purchase items.

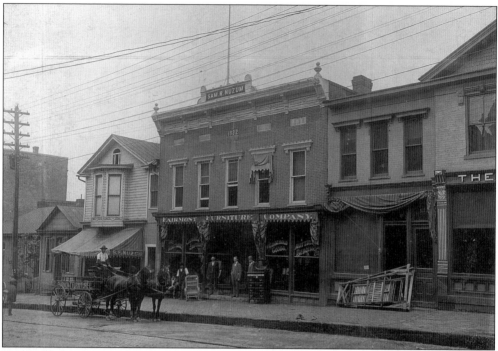

Pictured here in 1900, the Fairmont Furniture Company, located at 1117–1119 Main Street in Fairmont, was established in 1787 by Samuel R. Nuzum. He had this building erected in 1892. The delivery wagon, drawn by two black horses, was available six days a week to deliver customer purchases.

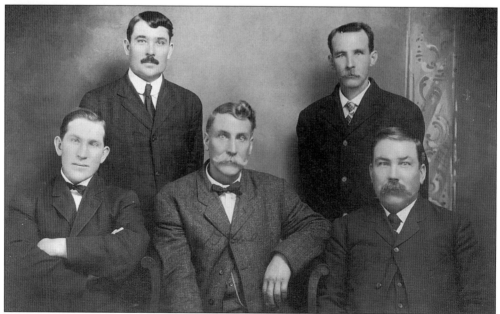

People speak of "keeping up with the Joneses," but in this case, it would be difficult since there are so many of them! Here are J.E., H.T., David M., Newton, and Jasper Jones—all prominent businessmen in Marion County—in a photograph taken around 1900.

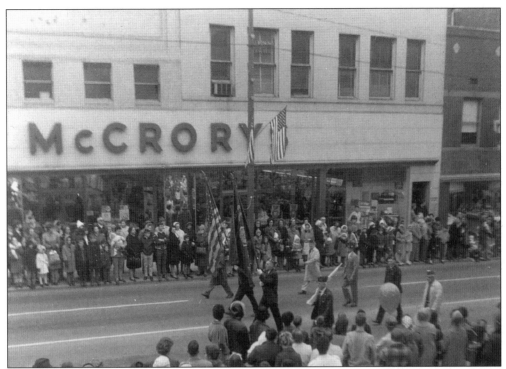

The five- and ten-cent store was quite popular in the first part of the 1900s although the prices soon went beyond the nickel and dime stage. McCrory served the needs of many residents of Marion County. J.C. Murphy and Woolworth were also popular for shoppers.

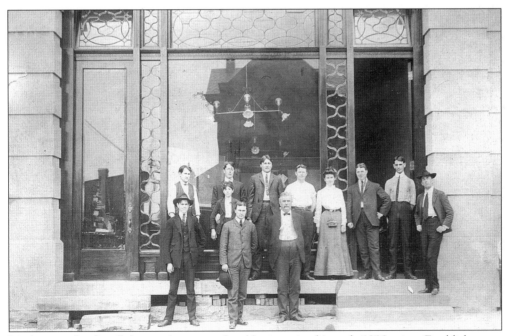

It's dress-up day for all the employees at a local business in this early 1900s view. Establishments such as this one have long gone out of business.

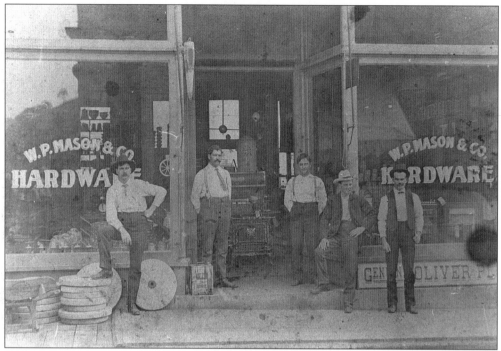

W.P. Mason & Co. Hardware in Mannington was very popular with local farmers and oil well workers, as well as with local residents. Apparently, the store is a bit overstocked on grinding wheels.

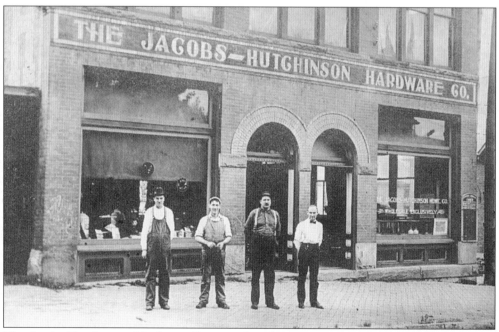

The Jacobs-Hutchinson Hardware Co. was the place to go when you wanted dependable merchandise. The store served county residents throughout much of the 1900s and tried hard to please all its customers. (Courtesy of Mrs. Arthur Stewart.)

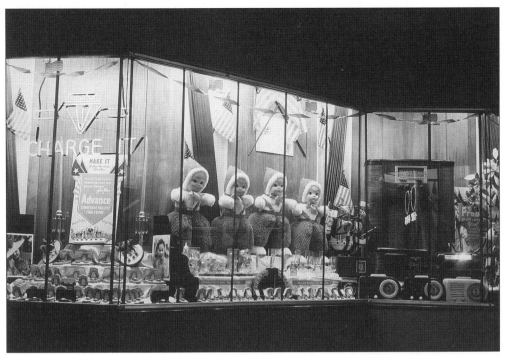

During Christmastime, employees at Hartley's Department Store in Fairmont often donated their own time to create magnificent window displays. On the left of the picture, one can see that the store has come up with the magic word to sell more merchandise—"charge."

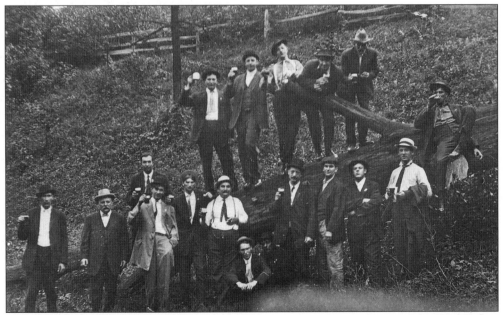

Very few local employees were as dedicated to their work as the employees of the Washington Street Brewery. Instead of having a "coffee break," they enjoyed (quite eagerly, you can be sure) a "beer break" and diligently tested the quality of their product. (Courtesy of the Ryland White collection.)

Vintage automobiles are parked in front of the Hays Building on Monroe Street in this mid-1920s scene. Next door is the office of the *Fairmont Times* newspaper. Later the office would move to the corner of Quincy and Adams Streets. (Courtesy of the Ryland White collection.)

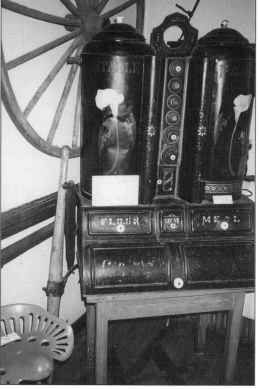

This antique cash register, on display at the West Augusta Museum in Mannington, has separate drawers for different products. The top three drawers are marked for flour, sugar, and meal. The top center of the machine holds a small compartment for each clerk so that each one's sales can be kept separate and tabulated at day's end.

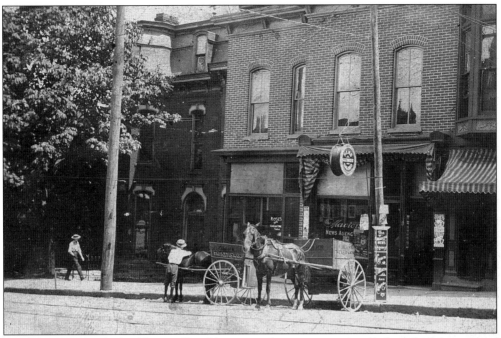

Work horses were the backbone of local businesses because customers had reached the point of expecting any business that sold large or heavy articles to deliver them. This was especially true in towns since many townspeople did not have a horse and wagon. Farmers who had horses and wagons, however, normally did their own delivering.

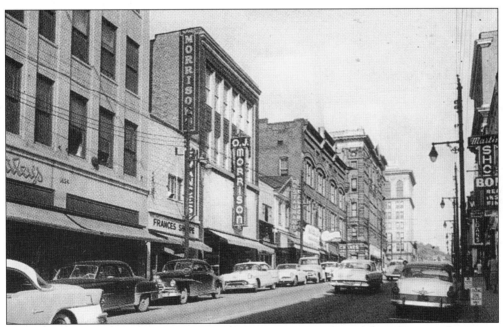

The mid-1900s saw many stores and establishments spring up along Adams Street in downtown Fairmont. Prominent among these were Hartley's, the Frances Shop, O.J. Morrison, the Palace Restaurant, Cranes Drug Store, Jones', and others. (Courtesy of Mrs. Arthur Stewart.)

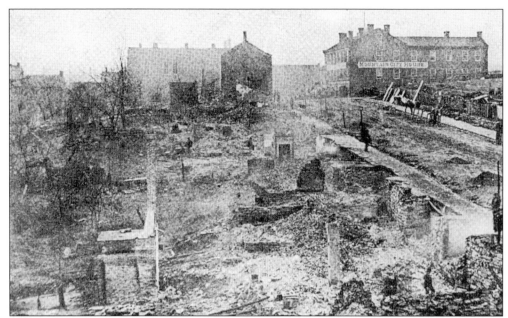

Fairmont suffered a disastrous fire in May 1876 that destroyed much of the downtown district. By the time the fire had been discovered, many of the buildings were beyond saving. There was no fire department then, but all the available volunteers passed buckets of water up a line so water could be thrown on the flames. All available bags of salt were also used. Luckily the wind shifted and the fire was contained to the area between Jefferson and Madison Streets.

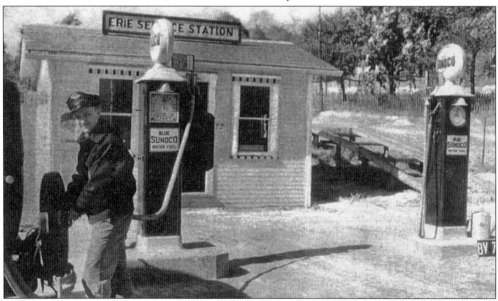

With the great increase in automobiles came the need for more gasoline filling stations. Perhaps some viewers can remember this Erie Service Station that dispensed Sunoco products. Note the antique pumps. These were a great improvement over earlier devices that required the station operator to hand pump the correct number of gallons into a marked compartment at the top of the pump and then run the fuel, by gravity, into the gas tank of the car. (Courtesy of Mrs. Arthur Stewart.)

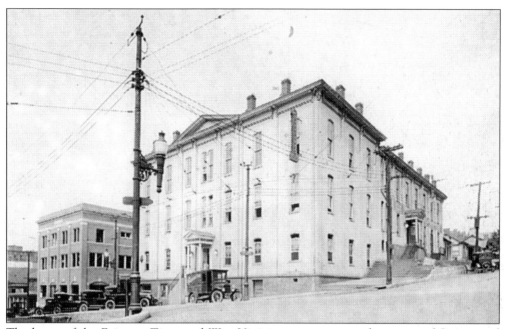

The home of the *Fairmont Times* and *West Virginian* newspapers at the corner of Quincy and Adams Streets in Fairmont was captured in this early 1930s photograph. The building had been used much earlier as the home of the Fairmont State Normal School and also as the Second Ward School.

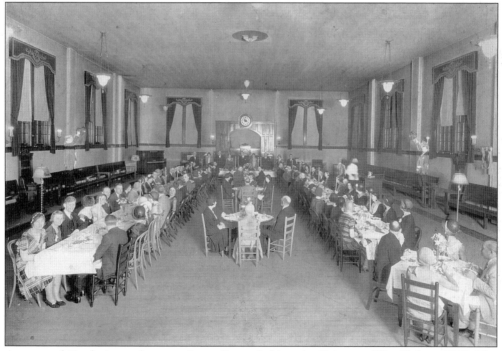

A group of Hartley's employees enjoy a dinner held at the Fairmont Elks Club in 1928. The store was expanding, profits were increasing, and more employees were sharing in the improving economy. Unfortunately, the Great Depression was not far away.

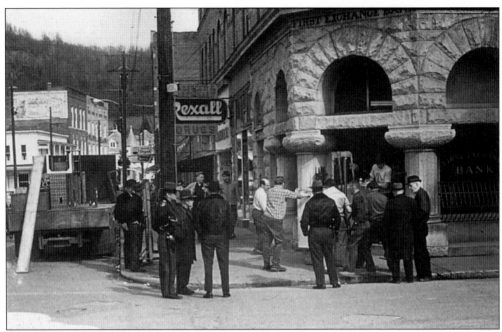

This interested group of people, including the local police, watches the installation of new units at the First Exchange Bank in Mannington. The police are likely there to prevent anyone from taking an illegal trip into the bank vault while work is going on.

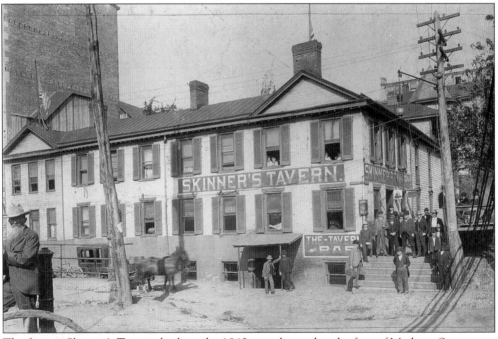

The famous Skinner's Tavern, built in the 1840s, was located at the foot of Madison Street near the suspension bridge that crossed the Monongahela River. Pictured here around 1880, the tavern became quite well known after 1852 when the B&O Railroad was constructed through Fairmont. A new tavern was constructed here in 1901.

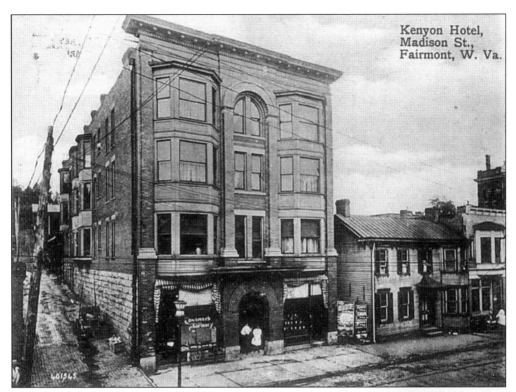

Kenyon Hotel, Madison St., Fairmont, W. Va.

Travelers debarking from the railroad depot did not have far to walk up Madison Street to reach the well-known Kenyon Hotel in Fairmont. The Kenyon and other nearby hotels eventually succumbed to the decay of age and the competition of newer lodgings, but they were famous in their time.

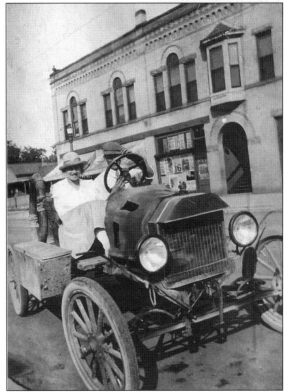

Car agencies began to make a mark in the marketplace as more and more people purchased automobiles. But new owners also needed a crash course in auto mechanics so that they could repair any breakdowns on the road. This driver has a large box mounted alongside the car to haul all the tools he may need in case of an emergency. (Courtesy of John Hamilton.)

55

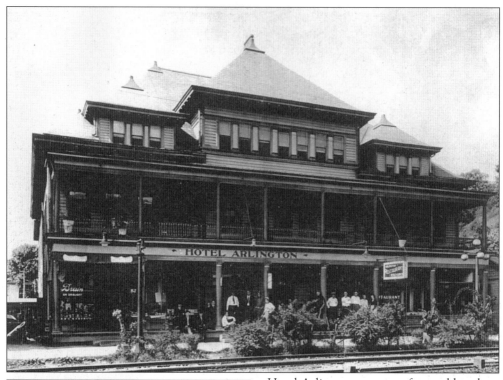

Hotel Arlington was one of several hotels in Mannington that handled the travelers brought into the area by the railroad.

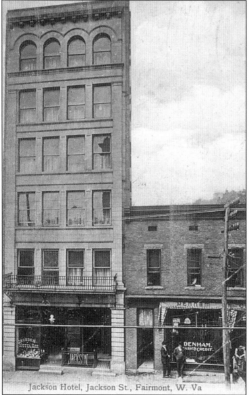

Jackson Hotel, Jackson St., Fairmont, W. Va

The Jackson Hotel on Jackson Street in Fairmont was a fine hotel for its time but did not keep in step with its competition. It was finally torn down.

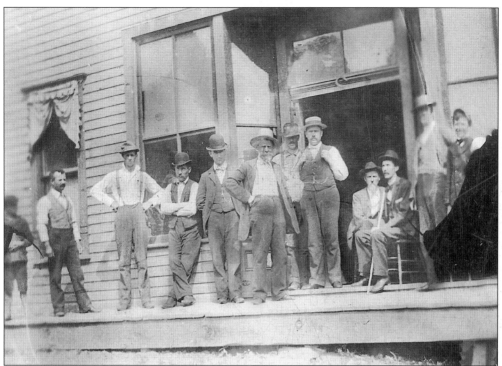

The 1895 photograph above shows a group of men discussing how to solve many of the world's problems. In the days before radio and television, people joined together in some convenient spot to hear and discuss the news and offer their solutions to the item under discussion. (Courtesy of John Hamilton.)

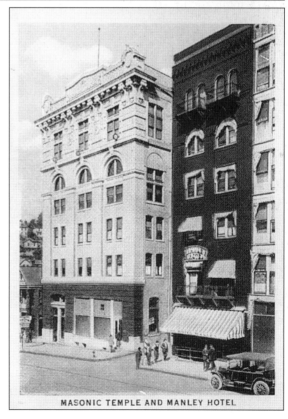

MASONIC TEMPLE AND MANLEY HOTEL

The Masonic Temple and the Manley Hotel on Jefferson Street in Fairmont are pictured here. The Masonic Order was quite pleased with its fine new temple, an excellent building in a fine location. The Manley Hotel was convenient to the Marion County Courthouse and offered reasonable rates. Many stayed here when working on official business at the courthouse.

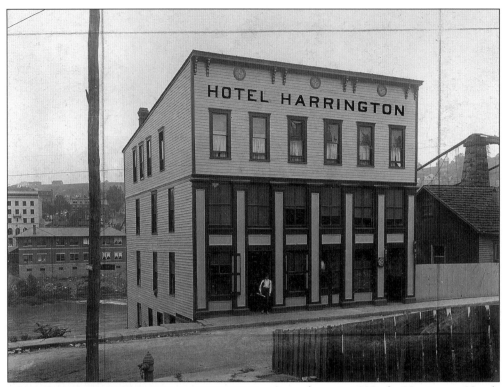

Seen above in 1898, the Harrington Hotel at 205–207 Water Street in East Fairmont advertised 40 rooms—all with an outside view—a large dining room, and a fine bar. What more could a traveler ask for? The suspension bridge to the west side was within easy walking distance.

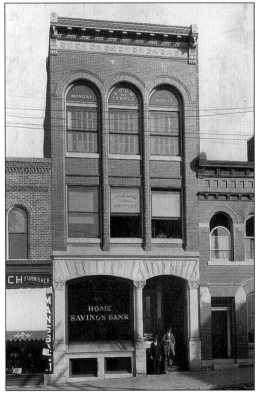

Home Savings Bank on the first block of Adams Street in Fairmont is visible in this 1898 photograph. Mansback Furnisher, a dealer in fine-quality men's clothing, occupied the building next door.

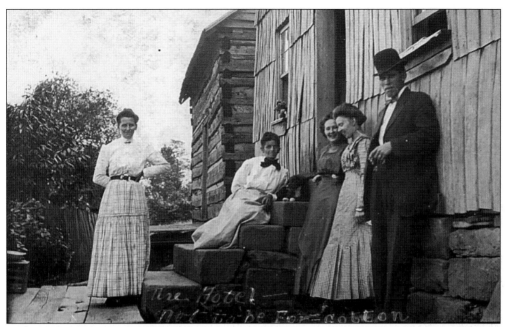

Not all hotels were in fine buildings with excellent accommodations. Those are usually not mentioned. This building is in poor shape and the log house next door may have been an early hotel.

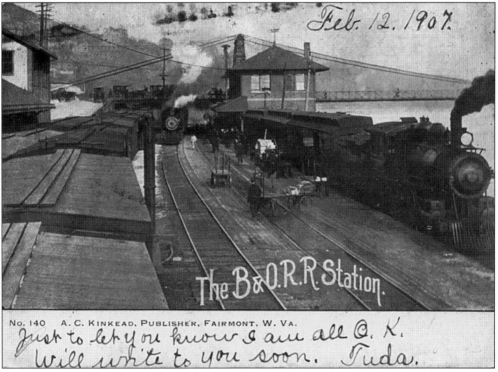

No. 140 A. C. KINKEAD, PUBLISHER, FAIRMONT, W. VA.

It's a busy time at the B&O Railroad station in Fairmont. The suspension bridge in the background has a number of horse-drawn vehicles starting to cross from the west side.

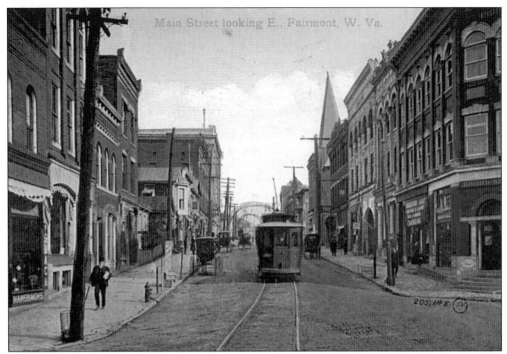

This view, looking from the south side of Fairmont, was captured around 1902. A number of establishments are on each side of Adams (Main) Street, and a church steeple is visible on the right. An early streetcar is traveling into the city and several horse-drawn carriages can also be seen.

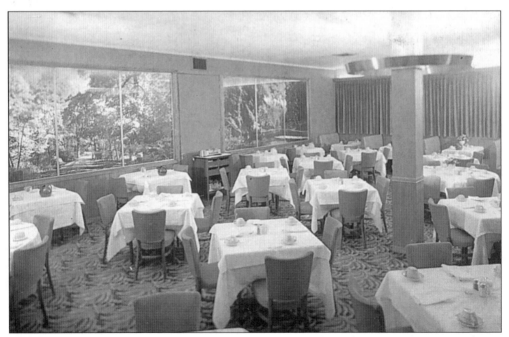

The Oak Room of the Fairmont Hotel is pictured here in the early 1920s. Elegance in dining was promised and delivered.

Four
EDUCATION

Marion County, like all Virginia counties, had no public education until 1863 when the State of West Virginia was formed. One of the first items addressed by the government of the new state was the creation of a system of free schools. As Marion County's population grew, the need for schools grew, and all sizeable towns in the county established an elementary school. Before long, the larger towns were able to establish high schools. Fairmont Senior High led the way, followed by East Fairmont, Rivesville, Monongah, Mannington, Farmington, Fairview, and Barrackville. Then came the rush to consolidate and all the high schools were lumped into three: Fairmont Senior (West Fairmont), East Fairmont, and North Marion (between Farmington and Mannington).

Higher education was also a high priority, and Fairmont State Normal opened on the corner of Quincy and Adams Streets in 1868. The school's enrollment grew, creating the need for larger quarters, and from 1893 to 1917, Fairmont State Normal School was located at Second Street and Fairmont Avenue. The need for even more room brought about a move to the hill above Locust Avenue where the school is located today. The school's name was changed in 1931 to Fairmont State Teachers College and then to Fairmont State College in 1943.

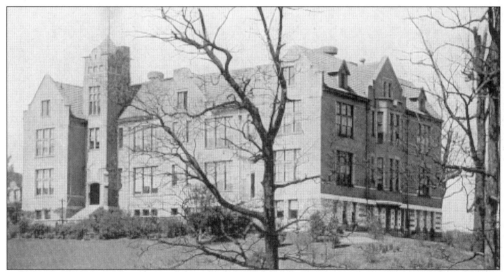

Located at Fifth Street in Fairmont, this was the first Fairmont Senior High. When a larger school became necessary, a new location was chosen at Seventh Street in Loop Park. Many opposed eliminating the park, but it was an excellent spot for the new school. This school was converted to Fairmont Junior High but torn down after proper repairs could not be made.

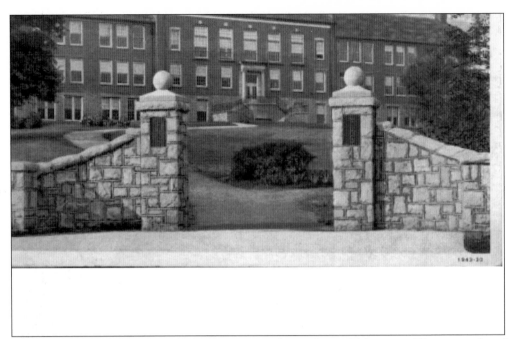

The new Fairmont Senior High School was certainly in a beautiful location. The remainder of Loop Park was soon put to good use as the site of several industrial plants.

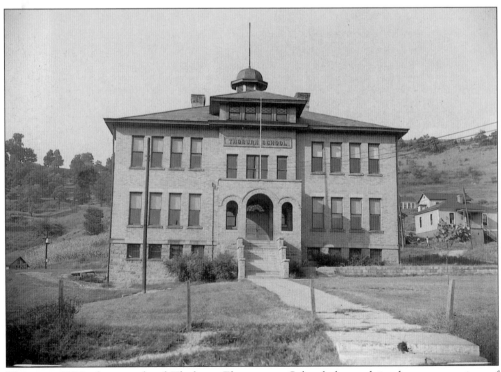

This is a 1920 photograph of Thoburn Elementary School, located in the west section of Monongah. The building was demolished a few years ago and a new elementary was constructed on the area that was formerly used as a playground.

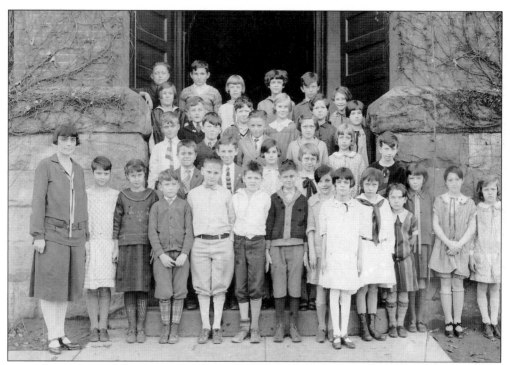

A teacher poses with her large classroom group. These youngsters tried to dress up and look "nice" for their formal picture. Most of them succeeded quite well.

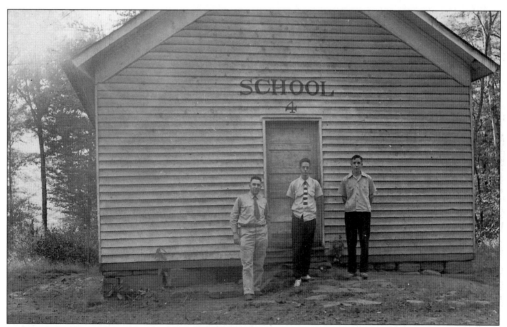

One-room schoolhouses were necessary in the days before school buses arrived to haul students several miles for instruction. The small schools managed to handle all the classes, but education sometimes suffered. This one-room schoolhouse is being inspected on September 28, 1941.

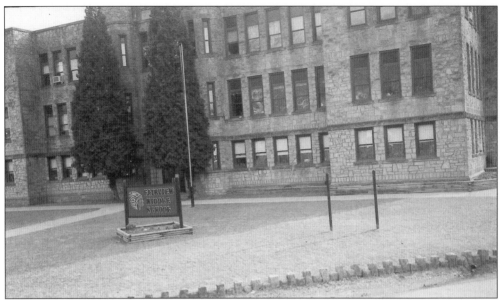

Pictured here is Fairview Middle School in a building that originally housed Fairview High School. When the high school was closed, the building served as a middle school and older students were bussed to North Marion High School.

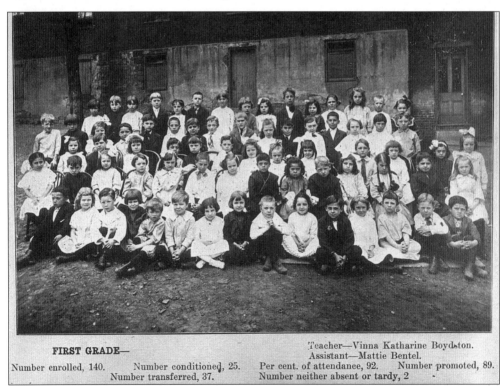

FIRST GRADE—

Teacher—Vinna Katharine Boydston.
Assistant—Mattie Bentel.

Number enrolled, 140. Number conditioned, 25. Per cent. of attendance, 92. Number promoted, 89.
Number transferred, 37. Number neither absent or tardy, 2

Pictured here in 1912 is the large first-grade class at Miller School in Fairmont. One hundred forty children were enrolled and 89 were promoted to the second grade. How could one teacher handle that many small children? Discipline was much different in those days.

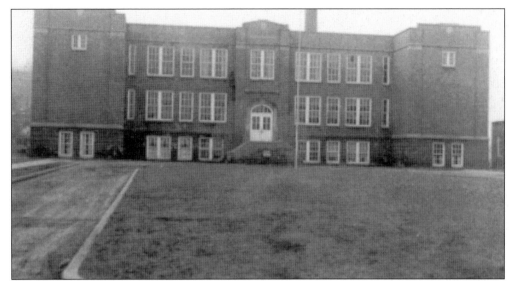

Barrackville High School was closed when the county consolidated into three high schools. (Courtesy of Ann Neptune.)

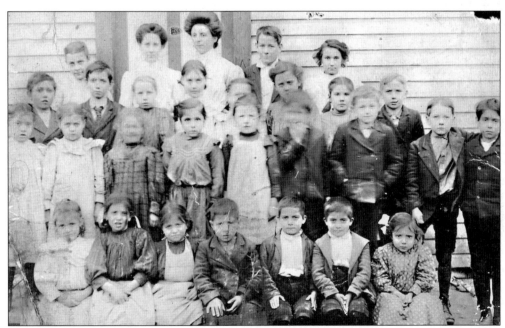

This class attended the one-room school on #63 Hill, south of Monongah. There is more than one child from several families represented here. One class would recite their lessons while the others listened and waited their turn. Often a "bright" student could skip one or more grades by mastering the lessons for a grade ahead of his or her normal position. (Courtesy of Betty Efaw.)

The 50th anniversary of the B.L. Butcher School, located on Fourth Street in Fairmont, was held on April 4, 1949, with a reception in the library where pictures of the school and students from former years were displayed on the bulletin boards.

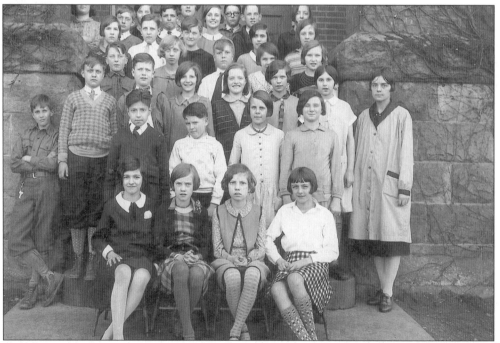

Members of this class are all "spruced up" for their end-of-the-year class picture. None of them look very happy. Perhaps the photographer forgot to say "Cheese!" Or perhaps they are unhappy about the school year coming to a close.

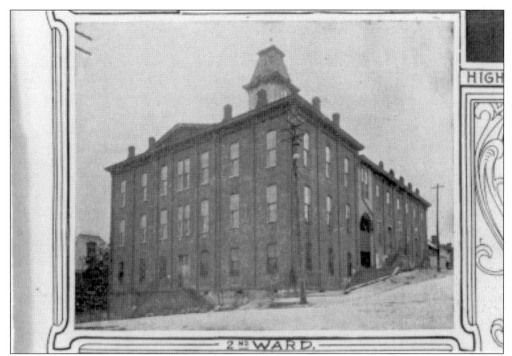

Second Ward School is seen here at the corner of Adams and Quincy Streets. Fairmont Normal School occupied this building briefly before it was given to the Second Ward for their school. Later the structure housed the offices of the *Fairmont Times* and the *West Virginian* newspapers.

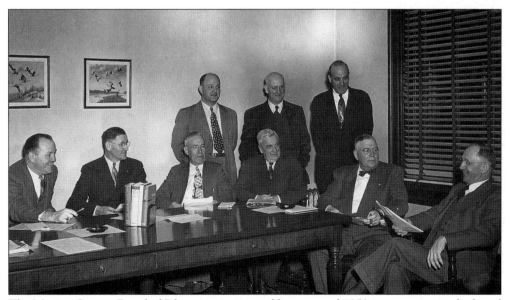

The Marion County Board of Education is pictured here around 1952 at a meeting in the board of education office at the corner of Gaston Avenue and Second Street in Fairmont. Marion County Superintendent of Schools J.J. Straight is at the far right.

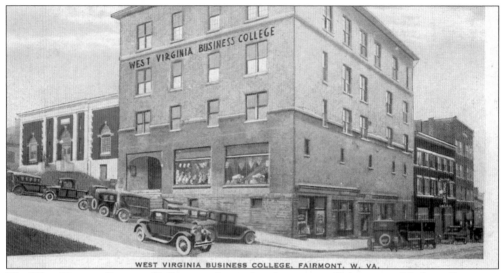

WEST VIRGINIA BUSINESS COLLEGE, FAIRMONT, W. VA.

The West Virginia Business College was located at the corner of Monroe and Jackson Streets in Fairmont. The building above it was originally the local post office and is now the home of the Marion County Public Library. The college location is now a parking lot.

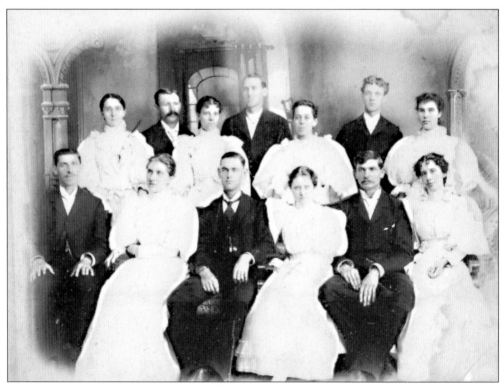

Photographed on June 14, 1895, this well-attired group is the graduating class from Fairmont State Normal School. They appear well educated and ready to go forth to assume a teaching position when the opportunity arises. (Courtesy of Helen Frankman.)

This summer 1937 class took the Education 239 course at West Virginia University in Morgantown. Several teachers from Marion County were enrolled in that class. Teachers needed to take several hours of instruction in refresher classes in order to renew their teaching certificates.

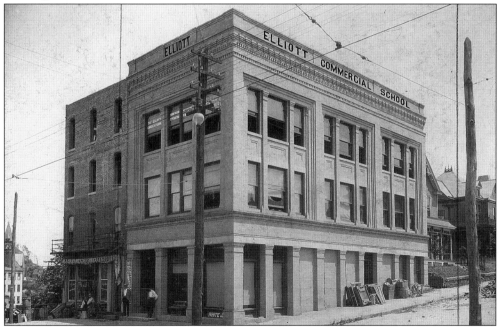

Elliott Commercial School in the new Stevenson Building at First Street and Fairmont Avenue is seen here c. 1901. Lantz Grocery Store is alongside the school with the Coal Run Ravine in the background.

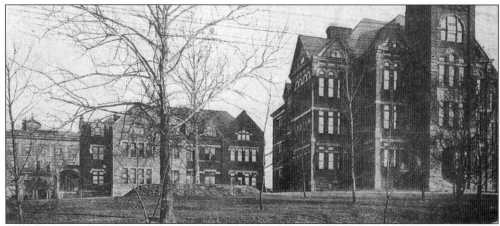

Fairmont State Normal School was located at Fairmont Avenue and Second Street. Note the mound at the left front with a tree growing from it. This mound is the source for the name *Mound* given to the Fairmont State yearbook. When more room was needed for expansion, the college moved to its present location in 1917.

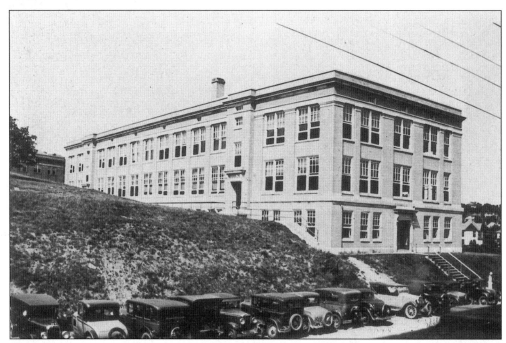

This is the Science Hall at Fairmont State College in 1932, when the college was known as Fairmont State Teachers College. It appears that even in those days parking at the college was quite difficult . . . and the parking problem is now worse. (Courtesy of the R.R. White collection.)

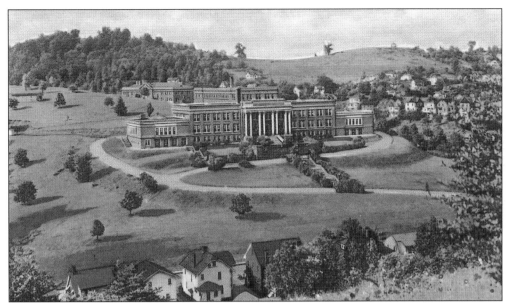

This view of Fairmont State Teachers College in 1935 shows the Administration Building and the campus of that time. The top of the Science Building can be seen over the top of the Administration Building, and the women's dormitory, Morrow Hall, is visible behind the Science Building. The view is much different today.

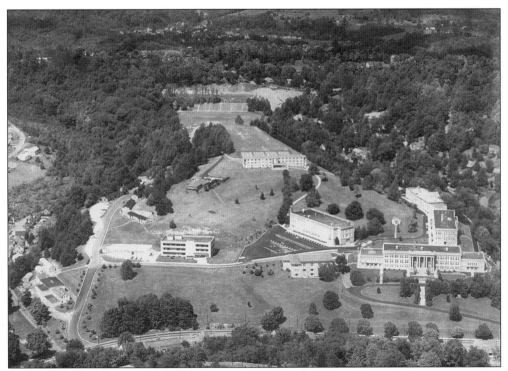

In this aerial view of Fairmont State College and the campus in the mid-1950s, the athletic field is in the back of the campus. Many changes have occurred and many more buildings have been added since this photograph was taken.

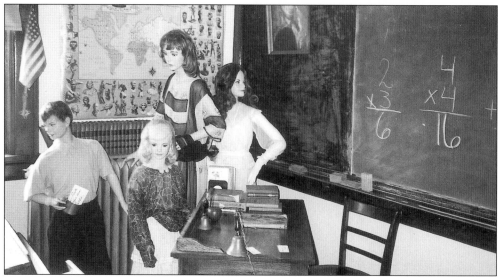

The West Augusta Museum in Mannington has this display that illustrates a one-room school. The models appear ready and willing to participate in any and all lessons.

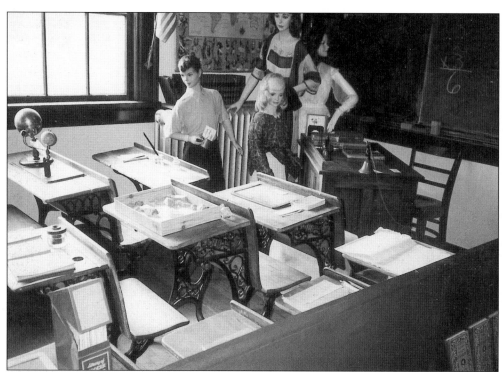

Students of today's schools can hardly appreciate the differences between the schools of 50 to 100 years ago and the schools they now attend, but many retired people can let their minds drift back and recall the schools they attended.

Five

LANDMARKS

When the great boom occurred with the development of the coal industry and the discovery of fields of oil and natural gas in Marion County, many people shared in the sudden wealth. Most spent their money erecting large houses. Famous architects were brought in to design these, and for a time, cost was no problem. Oil barons in the Mannington area had magnificent dwellings built; coal barons in the Fairmont vicinity did the same. The average person in the county had to be satisfied with a plain, but serviceable, dwelling and gaze with awe at the show homes occupied by the rich.

Marion County could boast of two structures that qualified as castles, and all visitors to the area made a special effort to see them. James Edwin Watson Sr. had a magnificent estate called "High Gate" that sat along Fairmont Avenue in Fairmont. It still survives today although the main structure is owned by Ross Funeral Home and the former carriage house has been refurbished and is now a tourist attraction. In East Fairmont, Clyde E. Hutchinson had a castle-like showplace on Morgantown Avenue. This was modeled after a Scottish castle and was named "Sonnencroft" (Home of Sons) since the Hutchinson's had eight sons. The structure finally had to be demolished due to its unsafe condition.

The residence of Brig. Gen. Clarence L. Smith on Quincy Street was one of the fine homes that was erected in Fairmont at the end of the 19th century. Much later, Hecks had a store at this location; bingo games are now operated in the empty building.

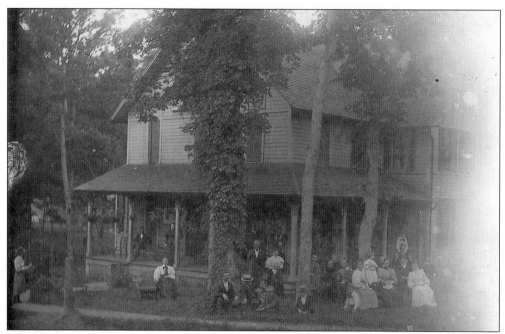

Large family gatherings, especially on Sundays and other days of leisure, were common in the days before radio and television. Of course, the ladies got little leisure if they had to prepare meals for the group. This family portrait was taken in 1897.

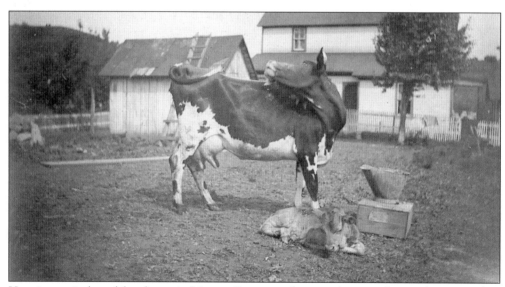

Here is a typical rural farmhouse in Marion County and a typical scene of a proud cow standing guard over her new baby—a calf not yet ready to run and play.

The residence of Thomas G. Watson in Fairmont, seen here in 1900, was later occupied by J. Fay Watson. Homes, such as this, were quite large and there was probably a lot of wasted space even with a large family living there. Lucky for the owner that coal for heating was cheap and easily available.

This attractive structure was once the residence of Samuel R. Nuzum, a prominent Fairmont merchant in the late 1800s and early 1900s. It is now Fitzwater's Personal Care Home on Locust Avenue in Fairmont.

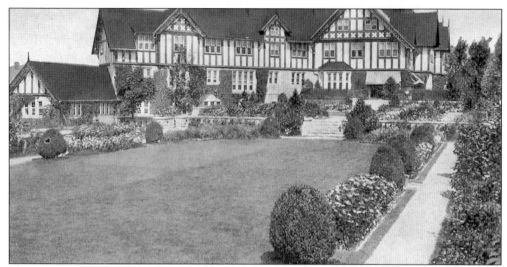

James Edwin Watson, the owner of the famous "High Gate" residence on Fairmont Avenue, employed a large staff just for the purpose of keeping the grounds immaculate.

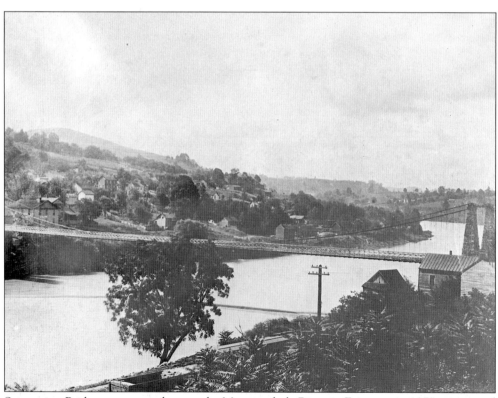

Suspension Bridge, constructed across the Monongahela River in Fairmont in 1852, connected East and West Fairmont and improved the economy of both groups. This bridge endured until about 1908, when it was razed and replaced by a steel structure bridge. That bridge is now closed for safety reasons, but new bridges have been constructed upstream.

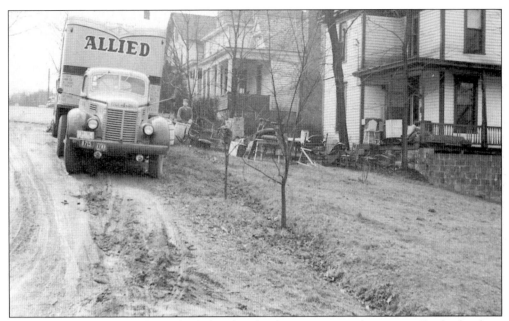

An Allied moving van is being loaded with a family's possessions for a move. Lucky for them that it is not raining since the furniture is unprotected. Rain would have made the roadway almost impassable in the days before the road was paved. The early paving material was brick.

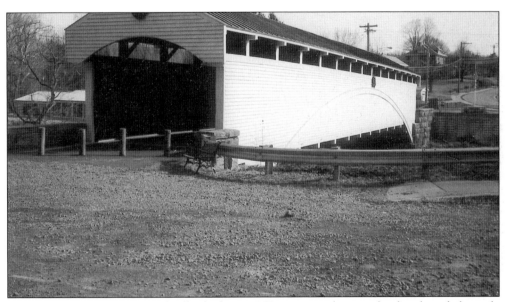

The covered bridge at Barrackville, built in 1853, is a true historic landmark and the only covered bridge remaining in Marion County—the others are no longer standing. The bridge was recently renovated and is now closed to vehicular traffic.

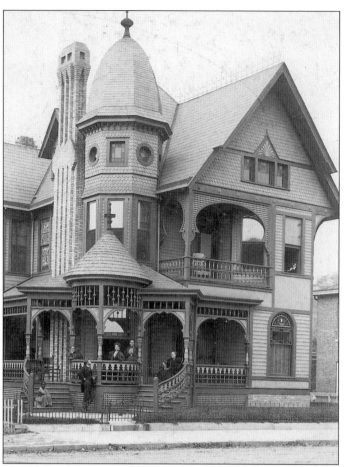

Shown here is the picturesque residence of Charles E. Manley, who served as the county clerk of Marion County in 1900. Manley also built and operated the Manley Hotel in Fairmont.

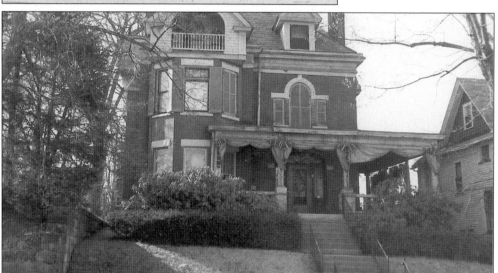

Fairmont Avenue was once lined on both sides with beautiful homes. Most of them have been sold and razed so that commercial establishments might be built. This is a 1989 photograph of the Hartley House on Fairmont Avenue near Seventh Street.

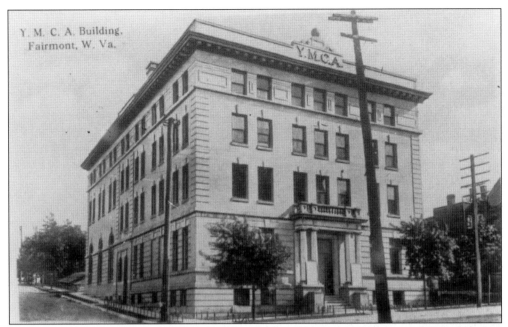

The home of the YMCA was located at the corner of Fairmont Avenue and First Street in Fairmont. This photograph was taken about 1920 when the YMCA was quite active. Membership declined—possibly due to the Great Depression—and the building later had to be sold. The Moose Lodge took over the facility.

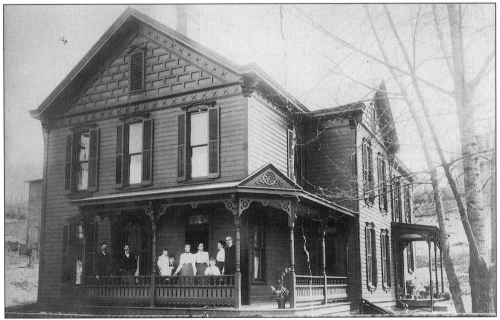

Large houses, such as the Hamilton House on Maple Avenue seen here in 1901, were the order of the day since homeowners either had large families or expected to have large ones. Additionally, elderly family members were normally kept at home and cared for in their later years. Here, family members enjoy the sunshine and the hope of an early spring. (Courtesy of John Hamilton.)

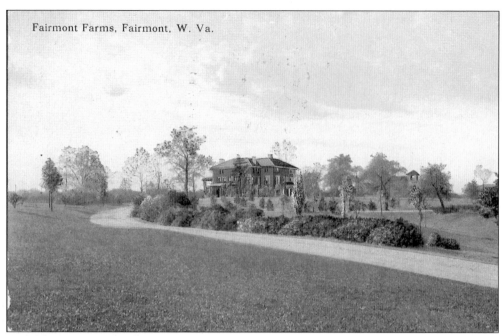

Fairmont Farms, Fairmont, W. Va.

Fairmont Farms, a Watson family residence in Fairmont, was a large home for a large family. The house was finally sold and made into apartments. This view shows the extensive grounds surrounding the home.

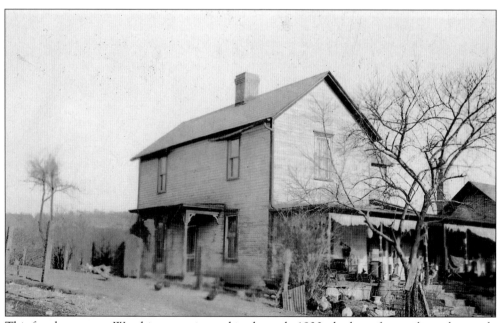

This farmhouse near Worthington, pictured in the early 1930s, had ten-foot ceilings that made the large rooms difficult to heat in winter but did help with cooling in summer.

This early first Baptist Church in Fairmont was dedicated on August 16, 1896. The current church is located at Fairmont Avenue between Ninth and Tenth Streets.

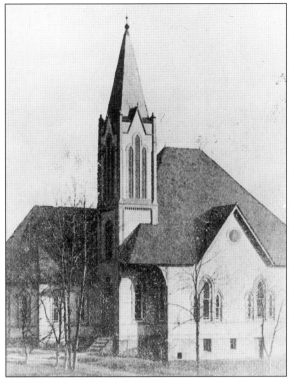

Many farms still exist in Marion and the surrounding counties even though this is not considered agricultural country. At left is a winter scene in rural Marion County.

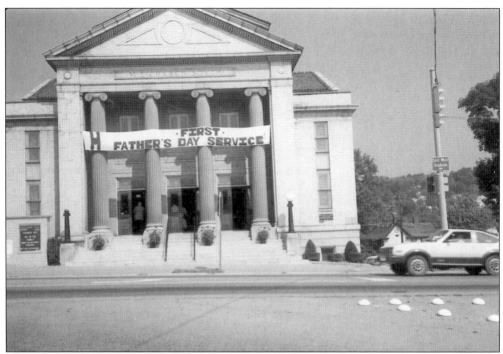

Marion County boasts the fact that it is the home of the "Father's Day Church" where the first observance of Father's Day was held. Central United Methodist Church at the corner of Third Street and Fairmont Avenue is the successor church to that original church just one block north where the first Father's Day service was held.

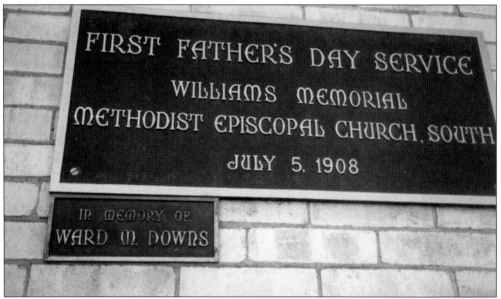

The first Father's Day service was held at Williams Memorial Methodist Episcopal Church, South, on Sunday, July 5, 1908. Grace Golden Clayton persuaded her minister to hold this service in honor of all fathers everywhere. However, she did not obtain widespread publicity and the idea was promoted elsewhere later on with much credit claimed there.

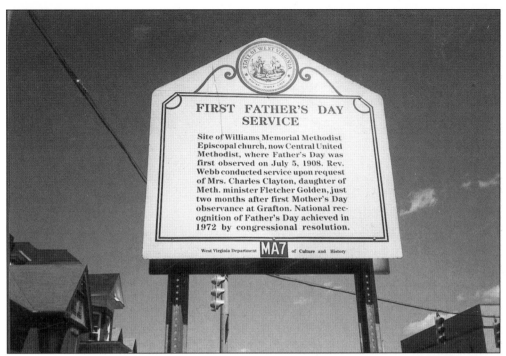

This Father's Day service was held two months after the first Mother's Day observance in Grafton, West Virginia. National recognition of Father's Day was finally achieved in 1972 by means of a congressional resolution signed by President Richard Nixon.

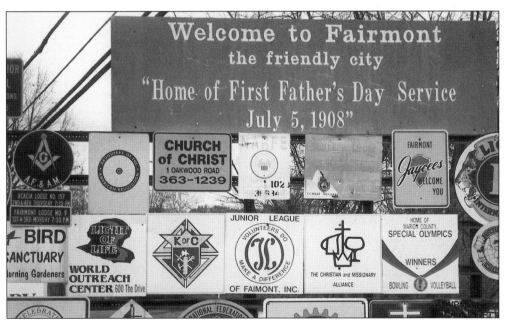

In recent years, Fairmont, Marion County, and the State of West Virginia have been making up for their failure to follow through properly and get proper credit given to Grace Golden Clayton for being the founder of Father's Day. Signs have been erected at all approaches to the city and governors' resolutions have been signed.

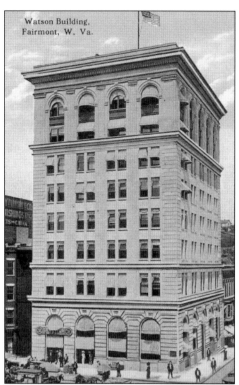

Watson Building,
Fairmont, W. Va.

Another Marion County landmark is the Watson Building at the corner of Jefferson and Adams Streets. The First National Bank occupied the lower floor of the building and the other floors were adapted for office space. This photograph was taken in the early 1900s.

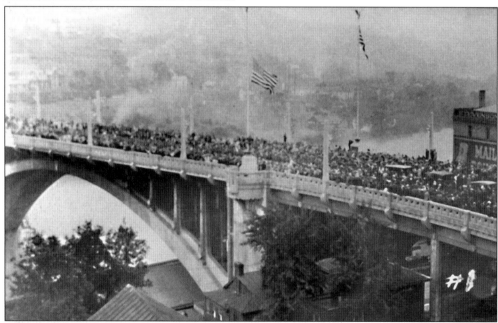

Another outstanding landmark in Marion County and Fairmont is the Monongahela River Bridge. Constructed to handle increased traffic, it was dedicated on May 30, 1921. A huge crowd, shown in this photograph, filled the bridge for the celebration, parade, and speeches. The bridge deteriorated badly over the years, was finally closed to traffic, and then rebuilt to its original specifications. Another huge celebration was held in 2000.

Six
COMMUNITY LEADERS

Marion County has produced a number of outstanding leaders. Several of the early ones were instrumental in the formation of Marion County from parts of Harrison and Monongalia Counties. Then, slightly later, others helped lead the struggle to have a new state created out of western Virginia. Leaders such as Francis H. Pierpont, William J. Willey, Waitman T. Willey, and Stephen Morgan guided our county well. To date Marion County has produced three governors of the State of West Virginia, three state treasurers, two secretaries of state, several U.S. senators, and some U.S. representatives.

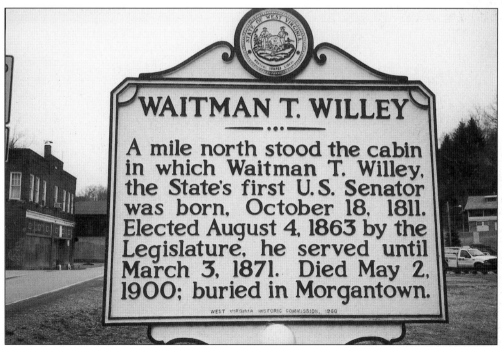

A plaque was erected in Farmington to honor Waitman Thomas Willey, a native son who was one of the main players in the struggle to have the State of West Virginia carved out of the Commonwealth of Virginia. Willey served as a U.S. senator from the Restored Government of Virginia and then, once the new state was created, served as the first U.S. senator from the State of West Virginia.

Rural Marion County has a number of dedicated farmers who take great pride in raising champion livestock and in the competition to produce champions.

Harry Shaw, a resident of Marion County, was the clerk of the West Virginia House of Delegates in1901. He supposedly played a major role in preventing Mannington supporters from getting a resolution passed through the House to create a new county from part of Marion. Mannington would have been the county seat of such a county.

Matthew Mansfield Neely, a Fairmont native, served as the governor of West Virginia and also as a U.S. senator from West Virginia. A skilled politician and outstanding orator, he was a dominant figure on the national political scene for many years.

A group of local politicians, most from Marion County, show their support for Democratic candidate William C. Marland for the office of governor of West Virginia. The candidate, seated at the left, does not appear happy but his campaign was successful.

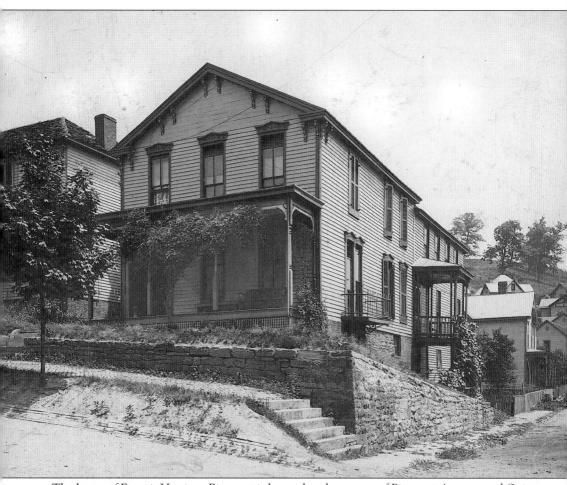

The home of Francis Harrison Pierpont is located at the corner of Pierpont Avenue and Quincy Street. Pierpont is known as the "Father of West Virginia" due to the leadership and guidance he provided in gaining statehood for West Virginia. He is credited with masterminding the strategy of creating a loyal government of Virginia to replace the one that voted to secede from the Union. He served as governor of this "Restored Government of Virginia" and led this government to agree to the partition of Virginia to form the State of West Virginia.

The large gentleman on the left is President William Howard Taft on a visit to the Watson family at their fabulous estate, High Gate. The Watsons enjoyed entertaining the rich and the famous.

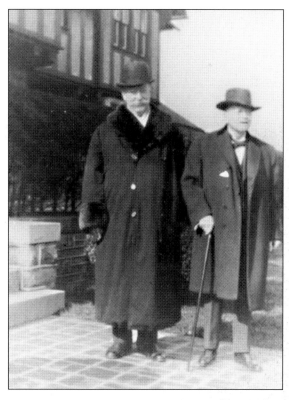

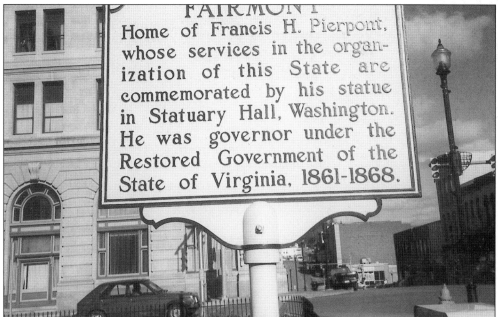

A plaque honors Francis H. Pierpont in his hometown of Fairmont. In recognition of his work to form the State of West Virginia, a commemorative statue of him stands in Statuary Hall in Washington, D.C. He was never the governor of the State of West Virginia even though he is often wrongly identified as the state's first governor.

A group of county and community leaders take time out from their discussions of problems and solutions to pose for the camera.

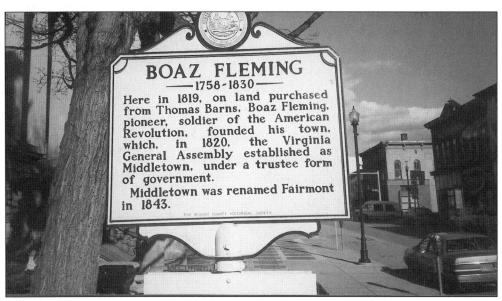

This plaque, mounted on the lawn of the Marion County Historical Society Museum, honors Boaz Fleming, who is considered the founder of Fairmont. Fleming tried hard to form a new county from parts of Harrison and Monongalia Counties but was able only to found the county seat.

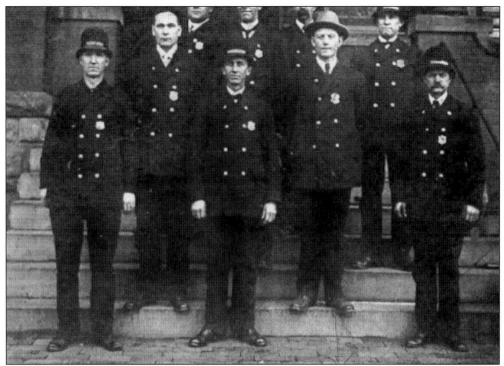

The members of an early police force are proud to be able to enforce the law. Their neat uniforms and tall hats tended to make these police easily identifiable. Any lawbreaker, when confronted by one of these stalwart lawmen, would quickly submit and go to jail quietly.

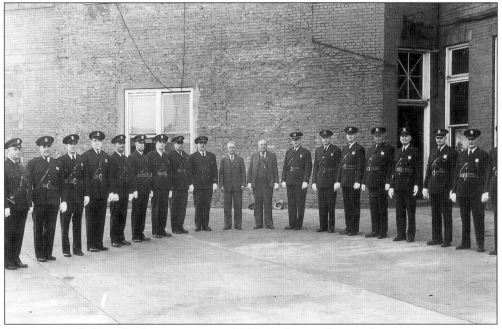

A group of well-dressed policemen poses in 1947. As the population of communities increased, the number of police needed to control the populace also increased.

County leaders joined together to discuss local problems and decide what to do with the county and its people. There are always problems to handle but there are good things, too.

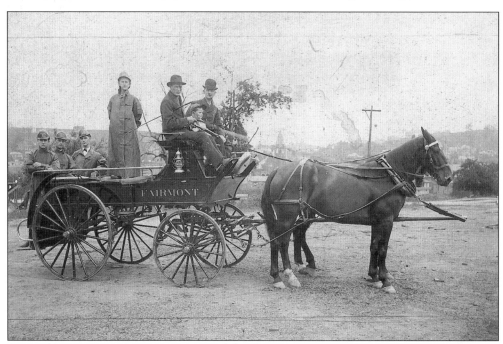

Pictured here is a new hose wagon secured for the Fairmont Fire Department in 1897. Prior to this new equipment being obtained, all fires had to be fought by means of a "bucket brigade." These firemen are quite elated with their new equipment and are eager to try it out.

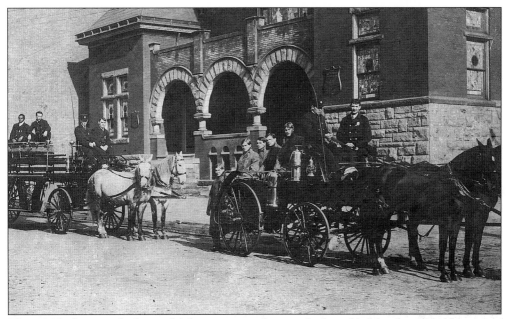

This 1900 photograph shows the hose wagon along with the added hook-and-ladder wagon and firefighters posing with their equipment on Monroe Street in front of Central Fire Station in Fairmont.

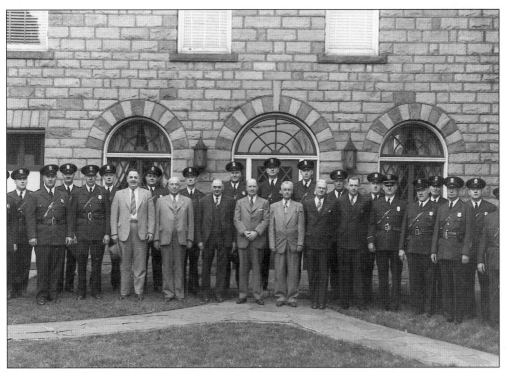

In uniform or out of uniform, a policeman's work is never done—whether it is out somewhere chasing criminals or dressing neatly so that a fine picture can be taken. This appears to be a group willing to do whatever is necessary to preserve the peace.

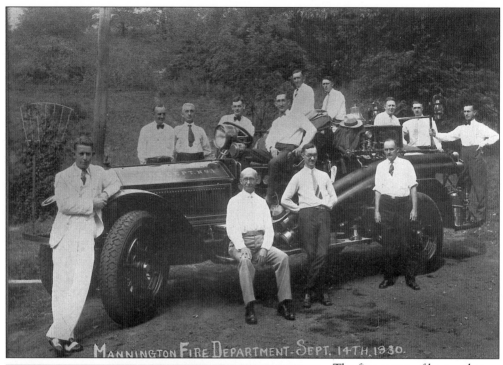

MANNINGTON FIRE DEPARTMENT - SEPT. 14TH, 1930.

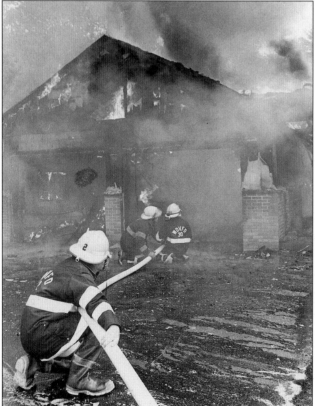

The fine teams of horses that faithfully pulled the fire equipment at the close of the 19th century and the start of the 20th century finally had to be retired once motorized equipment became capable of doing the same work. Above, members of the Mannington Fire Department, obviously proud of their new equipment, pose in their best clothes along with the new truck that apparently has not yet been used at a fire.

Fire equipment continues to be modernized and protective clothing improved so that fires can be better controlled. In this photograph, the fire appears to have gained too much momentum for the firemen to be able to save much, but they are definitely trying.

Seven

PARADES, GATHERINGS, REUNIONS, AND PARKS

Marion County has always been a willing participant in parades, especially any patriotic one. Various communities try to outdo each other—Fairview attempts to go all out on the Fourth of July, and spectators from all over the county, as well as elsewhere, flock there to observe the magnificent parades. Fairmont, Farmington, Mannington, Monongah, Rivesville, Grant Town, Barrackville, White Hall, Pleasant Valley, and others respond well whenever the call for a parade goes out.

General gatherings and reunions are not as common as they once were. At one time family gatherings or reunions were an excellent way to visit other family members and to renew old acquaintances. Today, however, the automobile allows people to travel long distances in order to meet and greet other people. The telephone is a convenient way to keep in touch with friends, and with the continuing use of computers, much of our communication is being done by e-mail.

Marion County had many parks in the early part of the 20th century that still provide hours of enjoyment to residents today. In these days of sedentary living, we need somewhere we can go to get the exercise necessary to good health. A day at the park can relax frazzled nerves and sore muscles.

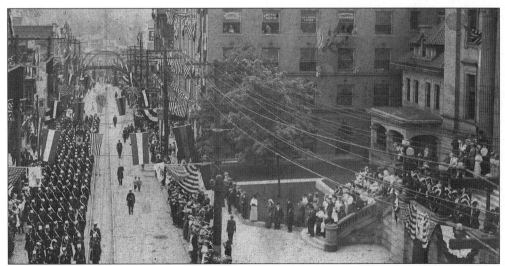

A patriotic parade comes up Main Street in downtown Fairmont. The new Marion County Courthouse is at the right with the county sheriff's home next to it. This building now houses the Marion County Historical Society Museum.

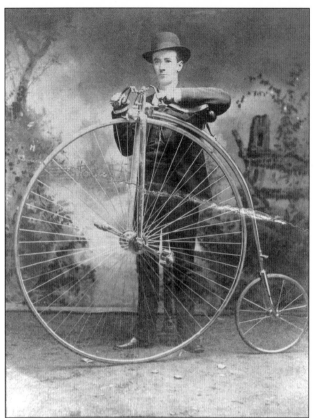

A young man poses with a large-wheel cycle, which was quite popular in the late 1800s. It would require considerable dexterity for a person to mount one of these and keep it erect. The small wheel in back helped maintain balance and was very important in steering the cycle. A regular bicycle seemed more sensible to ride, but this kind would attract more attention.

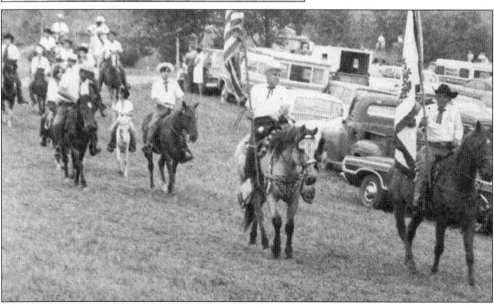

Here, riding club members prepare to participate in a parade. Gasoline- or diesel-driven vehicles may have replaced the horse in many activities, such as work and transportation, but there will always be those who feel nostalgia for the old days when mankind depended on the horse.

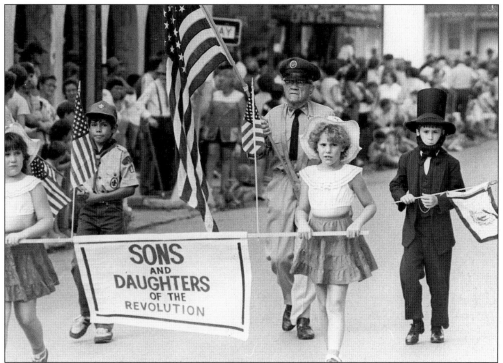

Pictured here is an entry in a parade held in the late 1980s. A familiar participant in any patriotic festival was the late Jack "Colonel Hardrock" Bunner, shown here proudly carrying the U.S. flag. The entry was submitted by the West Virginia Chapter of the Sons of the Revolution and the Marion County chapters of the Daughters of the Revolution.

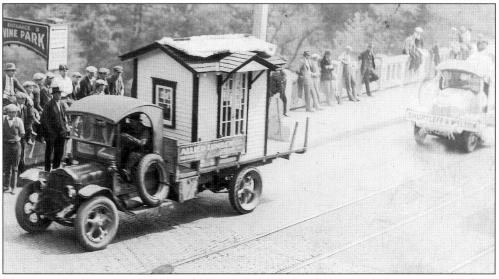

This motorized entry crosses the old South Side Bridge during a 1920s parade. The float, entered by the Allied Lumber Company, demonstrates some of their building abilities. Ravine Park was situated under the bridge in Coal Run Hollow, an area that is now a parking lot. Ravine Park was a very popular amusement spot before the Great Depression hit the area.

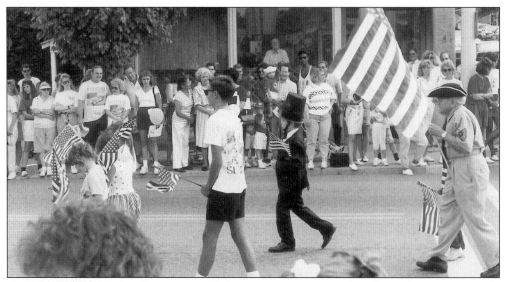

A patriotic parade in the late 1980s continues along Merchant Street in East Fairmont. Here, it passes the U.S. Post Office's East Side Station. Some of Marion County's communities, such as Monongah, Fairview, Farmington, Mannington, Rivesville and others, take great pride in establishing parades on those special days when we need to be thankful for what has been done in the past.

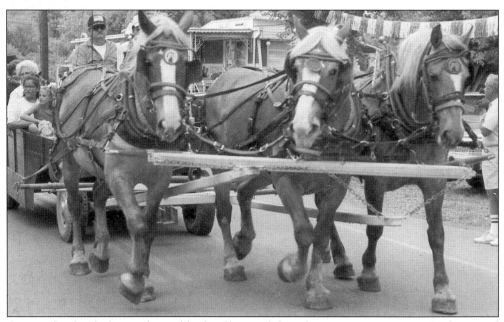

Again, what kind of a parade would it be if horses did not have a prominent part? And a special float, although nice to look at, is not really required. Here a three-horse team hauls a rubber-tired wagon that is loaded with people instead or freight or produce. Both spectators and riders enjoy it. Other horses, carrying people, are in the rear.

98

This antique fire truck was shined up so it could participate in the parade. The ladders and hose very likely are still serviceable. Antique vehicles are always a great draw in a parade and remind many people of the days when these antiques were new.

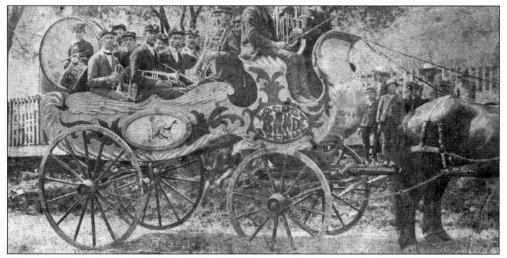

This must have been a fabulous carriage when it was new since it still appeared in great condition in the late 1800s at the time of this parade. Here, the Locust Avenue Band borrowed a vehicle and painted it to advertise the band. Undoubtedly, the band took time to perform some musical selections during the progress of the parade.

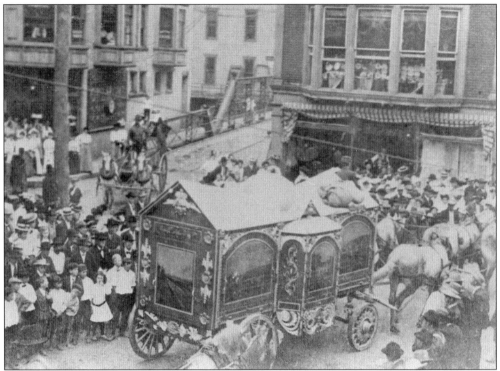

A huge parade forms at Mannington about 1900, a time when horses were still providing the "horsepower" to pull wagons and carriages. Everyone seemed to enjoy a parade even though preparation for some of them took a lot of time and energy.

Well-groomed horses draw an antique carriage along as it takes part in a parade. In parades, horse-drawn floats are still preferred over truck- or tractor-drawn ones. Sometimes, it appears that the horses enjoy being in the parade just as much as onlookers appreciate them.

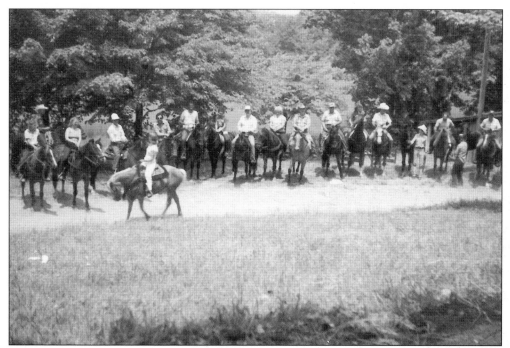

Riding club members and their mounts prepare to participate in the club activities. It looks like both humans and horses are in for an afternoon of enjoyable activity.

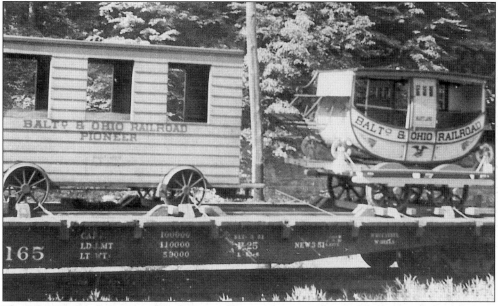

The B&O Railroad Company hauls some of its antiques on a flatcar. The car on the right is one of the first railroad cars put in service at Baltimore, Maryland, when the B&O was first started and may have been pulled by a team of horses walking along a path running parallel to the tracks. The railroad car was built much like a stagecoach and had little advantage over it except possibly a smoother ride. Steam engines were soon used to propel the car. The model on the left was also a very early type of railroad car.

Horses and ponies convey their riders to the larger group that is forming to go on a leisurely, well-programmed ride throughout the Bunner Ridge area. The young man is learning his lessons in managing his steed well and will soon be an accomplished rider.

Good grooming and much training have accomplished their intent. Both of these horses have managed to win grand prizes and they are undoubtedly well pleased. Their owners are very likely to go out and brag.

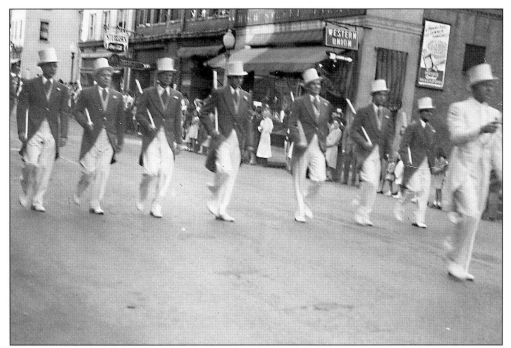

The Elks Lodge #294 Degree Team, quite formally dressed and marching in unison, follow the direction of their leader Bill Myers. They probably enjoy their performance even more than the spectators do. (Courtesy of the estate of Bill Myers.)

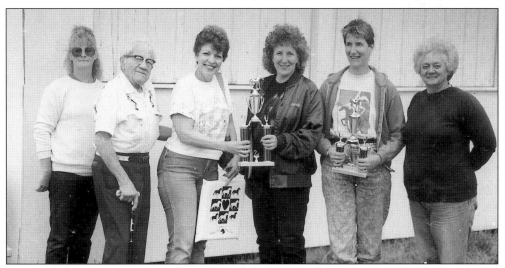

Members of the Bunner Ridge riding club show off the trophies that they won during a recent competition. Jack "Hardrock" Bunner donated the trophies and appears just as happy over the awards being given as the winners are themselves.

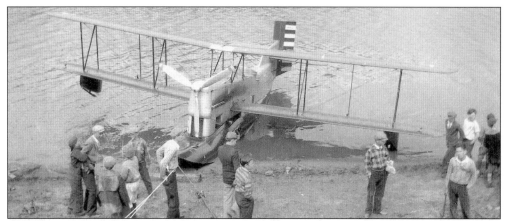

The arrival of a seaplane on the Monongahela River always created considerable excitement among the local populace. This one arrived in May 1929 and soon attracted a crowd. Several intrepid airmen, flying both land-based planes and seaplanes, did considerable flying over Marion County in the late 1920s and the 1930s. Many obtained their gasoline money by charging spectators a few dollars for a short ride in the plane.

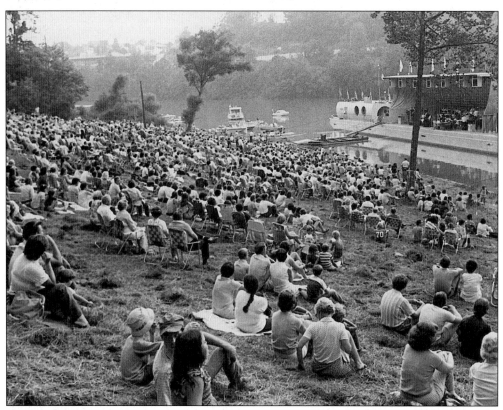

The Marion County Chamber of Commerce coordinated this spectacular waterfront concert along the Monongahela River. A wind symphony barge, *Point Counterpoint II*, was moored on the riverfront in Fairmont for a week and the orchestra held rehearsals on board the vessel during the mornings. The public was invited to attend and listen; this picture attests that many accepted that invitation and enjoyed the practices prior to the concert.

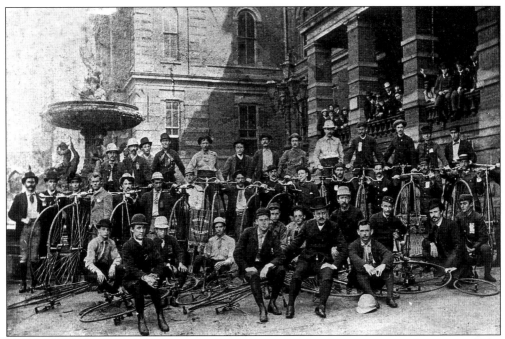

To see one person performing on and riding a large-wheel cycle was amazing, but to see such a large group of people riding these would be almost unbelievable. And yet, pictured here are over 40 people with their cycles. These individuals must have belonged to a cycle club that met in Mannington in the late 1800s to compare riding skills.

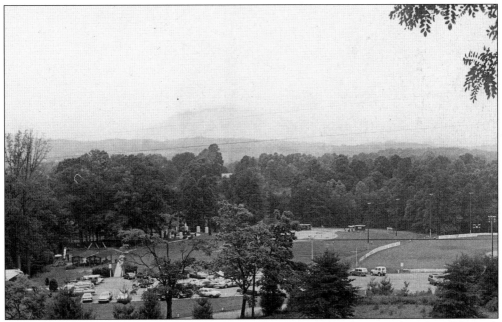

This is a view of Mary Lou Retton Park near Norway soon after the main features of the park were constructed. Lights were installed so that ball games could be played after dark. This park was a great addition to the playground facilities in the county.

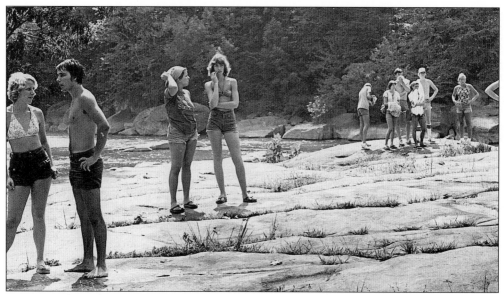

Young people enjoy a sunny day at Valley Falls State Park. Most have already been swimming and are now drying out. Valley Falls was, and remains, a popular place to go to relax and to enjoy a summer afternoon. A pavilion is available for parties and outdoor grills are available for any picnics.

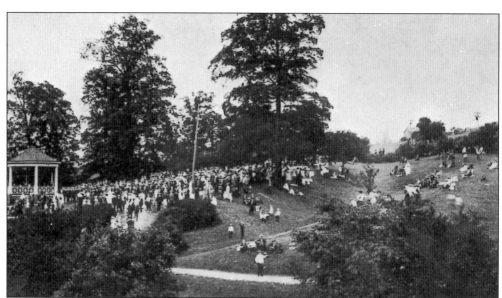

In this photograph, Flag Day is celebrated on June 15, 1919 at Loop Park in Fairmont. The park was a very popular spot as can be seen from the large number of visitors. The park's name was derived from the fact that the streetcar tracks made a loop around the park for the convenience of those going to and coming from the park. Unfortunately, it was chosen as the site of the new Fairmont Senior High School and the park had to make way for the advancement of education.

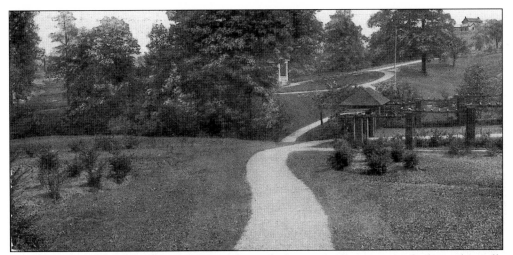

Another view of Loop Park shows some of the trails that enticed visitors to take leisurely strolls through the park. When the park was closed and the school constructed, the area soon began to be built up. Homes and industries arose where before was open parkland.

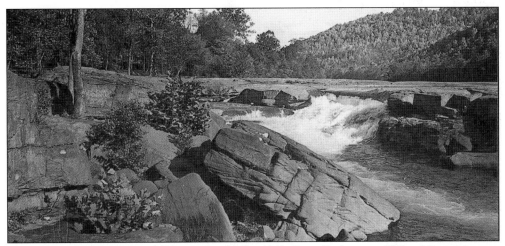

This scene captures a waterfall located at Valley Falls State Park, one of West Virginia's most beautiful state parks. It contains a number of colorful waterfalls that fall with considerable force due to the quick change in the elevation of the waterway.

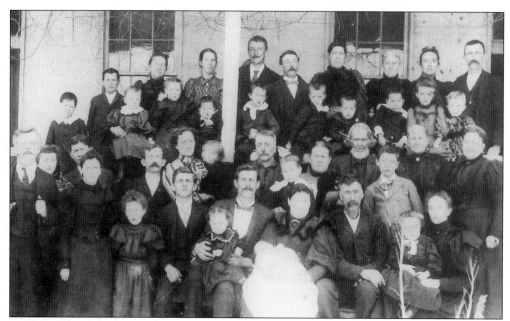

The 1900 Koon family reunion, seen above, was held at the family home on Swisher Hill near Worthington and involved several generations. Large families were normal in those days. The house, minus its porch, is still standing, but no one has resided in it for many years.

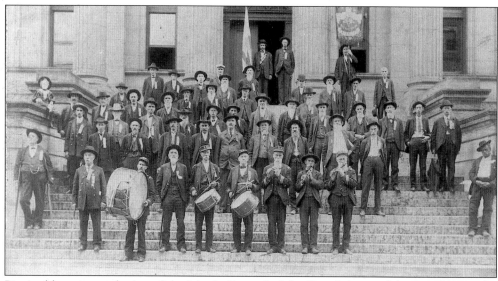

Pictured here is a gathering of the Meade Post #6 of the Grand Army of the Republic in the early 1900s. Several of the veterans appear to be fairly spry yet. Reunions began to occur more frequently as the ex-soldiers aged and their numbers declined due to death.

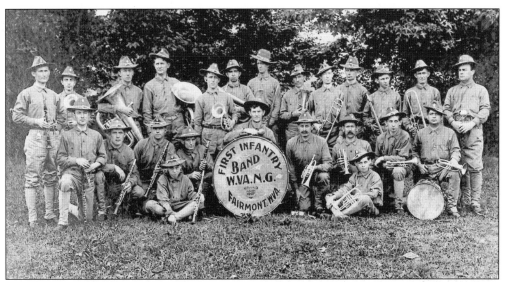

The first infantry band of the West Virginia National Guard was based at Fairmont. This photograph, taken in late 1917 or early 1918, shows the band members, many of whom are anticipating an early call to active duty as the United States' involvement in World War I intensifies. (Courtesy of R. White.)

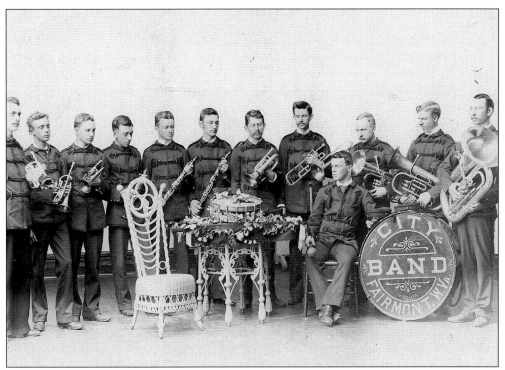

Members of the Fairmont City Band are seen here all decked out in fancy uniforms around 1898. Bands were very popular in those days since no radio or television was available to entertain people. If you wanted entertainment, it had to be live entertainment, and the musicians were happy to oblige. It seemed that each community managed to have a band.

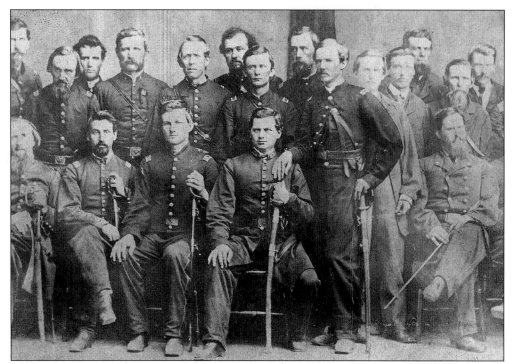

Marion County was strongly pro-Union, but many residents stayed loyal to Virginia and joined the Southern forces. Confederate veterans remained dedicated to their "lost cause" while Union veterans took great pride in their ultimate victory in the struggle. War memories were still vivid to the veterans participating in this 1880 reunion.

A group of Confederate veterans attend the Ice Reunion held at Barrackville about 1900. These men look as if they were ready to renew hostilities if someone like General Lee were to come to lead them. They would assure everyone that the South would have won if Stonewall Jackson had not been killed by one of his own men.

This large reunion was held around 1905 at a location thought to be Traction Park near Monongah. The park became quite popular since it was near a streetcar stop and thus easily accessible. The Traction Company established this park and erected a grandstand and a dance pavilion. Early residents stated that "the joint really jumped" on Saturday nights. Dances were held on Saturday nights and baseball games took center stage on Sunday afternoons.

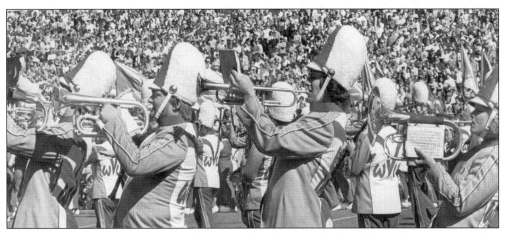

The West Virginia University Marching Band performs at the football stadium on a Saturday afternoon. Although the university is located in Morgantown in Monongalia County, many of its students—and usually several band musicians—are from Marion County. Residents of Marion County support West Virginia University with much fervor.

Again, work horses take center stage in a local parade. There is still a considerable amount of rural area in Marion County, and local people take great pride in their livestock. So, whether it is competing at local fairs or marching in parades, horses and other livestock are brought forth by their owners with great pride.

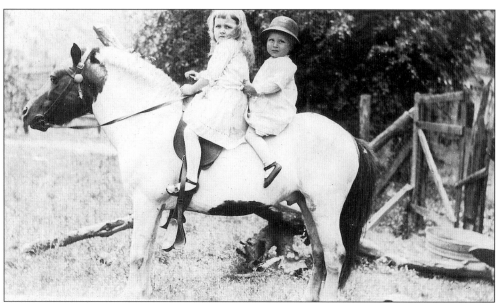

This is a 1922 or 1923 picture of two youngsters ready for a great ride on a willing pony. They may not be going to ride in a parade, but they certainly feel that they could not have it much better than this.

Eight

COMMUNITIES

Many communities, some quite small, combine to form Marion County. Some were founded early and have grown gradually while others have declined in size over the years. Many of the towns grew out of coal camps created by mine owners to house the many workers, mostly immigrant, imported to work the newly developed coal mines. We look at a map and see Fairmont, East Fairmont, Mannington, Farmington, Barrackville, Fairview, Grant Town, Monongah, Whitehall, Kingmont, and Rivesville. All these have a rich history. But we cannot overlook Colfax, Levels, Hammond, Millersville, Montana, Baxter, Chesapeake, Pine Grove, Everson, Thoburn, Chatham Hill, Rachel, Consol No. 9, Worthington, Chiefton, Hutchinson, Bunner Ridge, Meadowdale, Catawba, Baxter, Dakota, and Boothsville. They too have much to tell. Then we also have Dakota, Monumental, Chesapeake, Eldora, Hoodsville, Smithville, Basnettville, Glover Gap, Bingamon, Joetown, Hebron, Seven Pines, Grangeville, String-town, Brink, Condit, McClellen, and Bentons Ferry. Each resident of these communities is an important part of this county, and many residents even live outside these communities but also play an important part in Marion County's story.

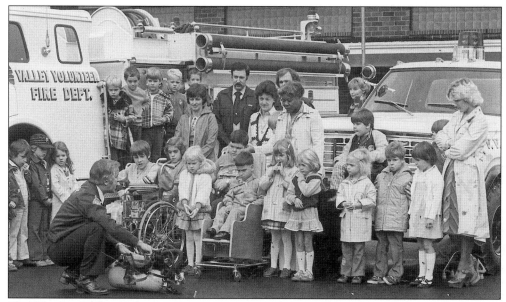

This Pleasant Valley Volunteer Fire Department volunteer demonstrates some equipment to a group of children. Some of the children are handicapped and were given special attention and instruction by the firefighters.

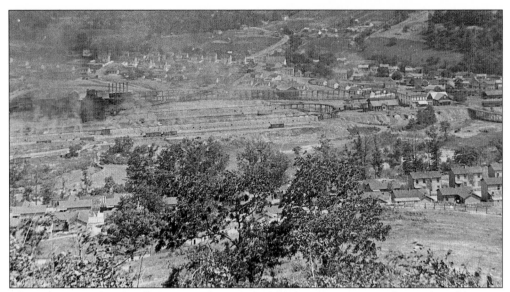

This is a panorama of early Monongah around 1905, but just two years later a horrible mine explosion occurred at Mine No. 6 and No. 8 on December 6. Most of the houses seen here are the homes of mine workers, a great many of whom were brought from overseas strictly for the purpose of working in the mines. Much of the economy of Marion County in the early 1900s was dependent on coal mining.

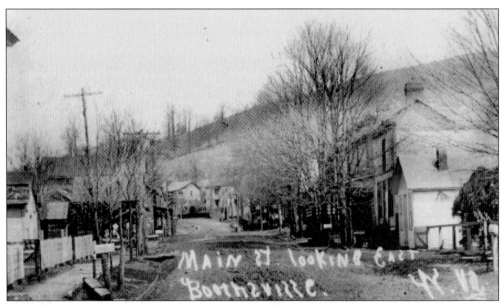

In the early days, Boothsville, located along the important Beverly Turnpike, was a thriving community, and traffic and business flowed through it. This view, looking east, shows the Main Street of Boothsville. Streets had not yet been paved and could be a muddy mess when the weather was inclement. When a railroad was constructed along the West Fork River to serve the many mines starting to open up there, traffic began to bypass Boothsville and follow the railroad. Boothsville began to decline and the economy suffered. (Courtesy of Betty Dowdell.)

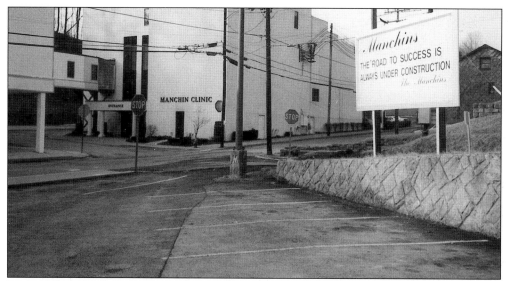

Pictured here is the Manchin Clinic in Farmington. The town was so named because the principal industry there was farming, though it was briefly called Underwood after a railroad executive and Willeyville or Willeytown after William J. Willey, the first man to have the town surveyed and laid out in lots. Neither of these names stuck and both were soon replaced. Most of the residents seemed to prefer Farmington and voted to go back to that name.

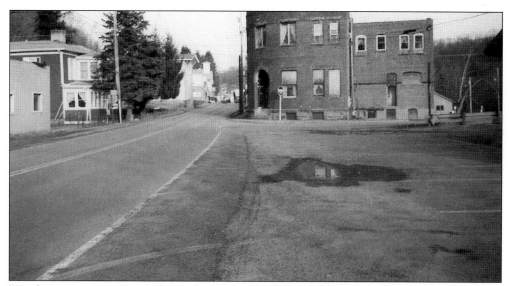

Worthington was one of the early towns founded in the county and has not changed significantly over the last half century. It has one long main street where most of the homes and businesses are located. It has a parallel lower street, appropriately called Water Street, which suffered the indignity of being under water whenever floodwaters came through the area.

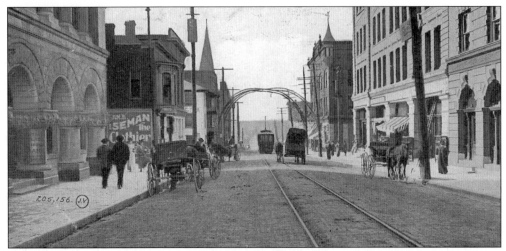

Downtown Fairmont is seen here in the very early 1900s. Streets are now paved with brick—a great improvement over the original dirt avenues that could be very dusty in dry weather and a muddy mess when it rained. Before the bricks were installed, some enterprising merchants had rough wooden planks laid down to direct traffic into their stores. It was a chore to attempt to cross a street to reach another store when the street was a mass of mud.

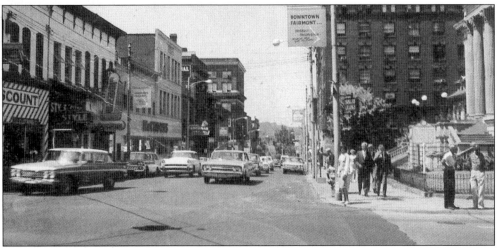

This view looks towards downtown Fairmont from Jefferson Street in the mid- to late 1950s. Streetcar tracks were blacktopped over once the streetcars were discontinued in 1947 and replaced by buses. Many people in Marion County today would love to have the streetcars back.

116

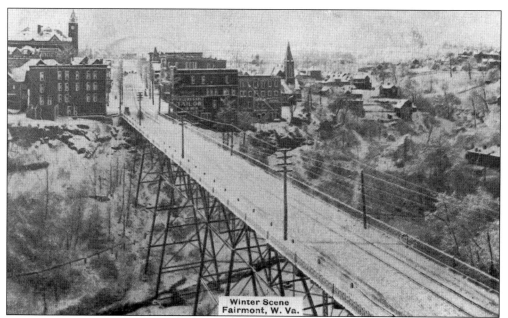

In this 1910 view of the original South Side Bridge and Coal Run Hollow there is also a view of early South Fairmont. The steeple at the far left belongs to the Fairmont State Teachers College. From the bridge, Fairmont Avenue continued southward to about Twelfth Street, and a number of houses and businesses were constructed at this end of Fairmont Avenue. The South Side was beginning to be developed and many beautiful homes were beginning to be constructed along Fairmont Avenue.

This view of Fairview shows the changes that have occurred on Main Street over the past century. The town used to be a center for the hustle and bustle of nearby coal mines, as coal trucks rushed through and miners traveled to work. But a terrible tragedy at Consol No. 9 Mine closed that mine, and another disaster, this one occurring at Loveridge Mine of Consolidation Coal Company, caused that mine to be closed. Attempts are being made to open at least part of the Loveridge mine.

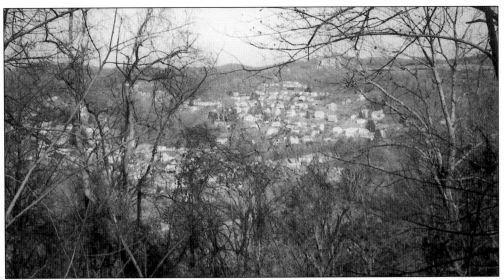

At one time Grant Town, viewed here from an opposite hill, had one of the largest coal producing mines in the world. The town seemed to grow up almost as a part of the mine office, preparation plant, and supply house. But things change over the years—eventually the coal reserves ran out and the mine had to be closed. The demolition of the coal property buildings removed all traces of the once prominent mine.

Photographed here is the village of Idamay. Miners' homes, a company store, a company doctor and office, and a school were a few of the things set up by the coal company when they brought miners in to work the new mine. Consolidation Coal Company operated this mine for years and then finally sold it to Bethlehem Mines Corporation, a subsidiary of Bethlehem Steel. It was then known as Bethlehem Mine No. 44. The mine has now been closed for several years. Homes have been renovated since they were sold to the occupants who wished to purchase them.

118

This view of Idamay was taken from the upper part of the town. At right center are some of the mine buildings that were allowed to stand since they were enclosed by a heavy metal fence and could be protected from vandalism. Today, the mine buildings, still in excellent shape, are being used by civic groups and others.

The town of Carolina, seen here, was the sister mine and town to Idamay. Consolidation Coal Company started this mine by the same method and around the same time that Idamay was begun. Carolina was later sold to Bethlehem Mines Corporation, just as Idamay was, and was then known as Bethlehem Mine No. 43. It was closed when coal could no longer be mined economically. The houses were sold to individuals at reasonable prices.

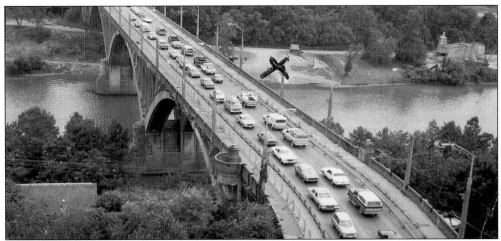

In this *c.* 1960 view, noticeable decay on the Monongahela River Bridge had not yet set in or at least had not been discovered. Much later the decay would reach the point that traffic on the bridge had to be restricted to two lanes and then finally the bridge had to be closed for good. However, with the aid of a very large grant, the bridge was torn down to the supports and the entire bridge rebuilt. It is now called the "Million Dollar Bridge" or the "High Level Bridge."

This was originally the Marion County sheriff's home. When West Virginia decided that homes would no longer be furnished to sheriffs, the Marion County Commission decided that this building would be leased to the Marion County Historical Society for use as a historical museum. Over the years a number of items have been given or loaned to the museum and they are on display for the benefit and education of the general public.

This sign is on the lawn of the Marion County Historical Society Museum. Admission is free and all those who have an interest in history and historical preservation are invited to visit and, hopefully, will help the society by their presence and support.

The old Wilson Schoolhouse in Mannington is the current home of the West Augusta Historical Society Museum. The society has a great number of pictures and artifacts on display, and in the rear of the building are an old railroad engine caboose and a restored log cabin.

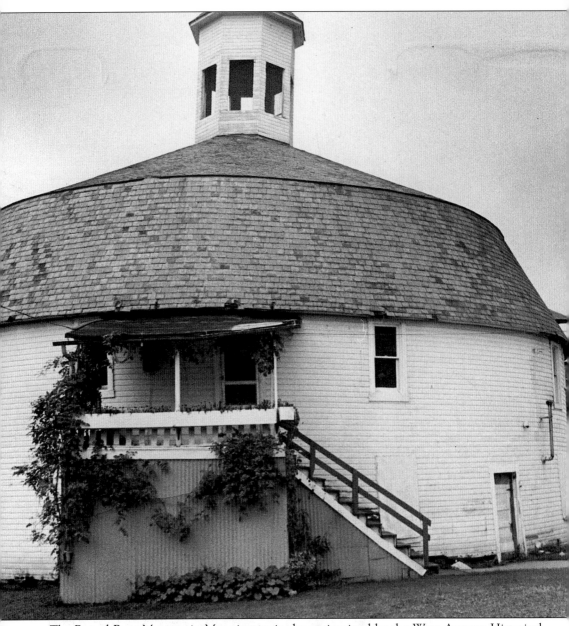

The Round Barn Museum in Mannington is also maintained by the West Augusta Historical Society. Originally a large dairy barn and now adapted for use as a museum, the Round Barn displays a number of old tools and artifacts for visitors.

Nine
MISCELLANEOUS

Marion County is a relatively new county, but it does have a historic past and its inhabitants have done much to warrant their exploits being featured in historical records. Much has been written about outstanding frontier warriors and those who braved the perils of the wilderness to found new homes. The county has also had its share of outstanding political figures, giants in the field of education, coal and oil barons, and industrial leaders. They all deserve credit and thanks from those of us who have enjoyed what they helped to create. But we should also give a great "Thank you!" to those unheralded men and women who, without any special recognition, went about their daily tasks without complaint and left this county a better place for their having been a part of it.

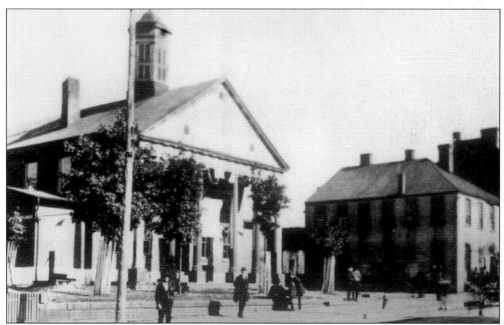

Marion County was founded in January 1842, and in April, the new county court began to take care of legal matters. The first public building authorized to be constructed was a jail; the second was a courthouse. The new county court wanted the structure to be a thing of beauty but also practical, and they succeeded. The structure on the left in this photo is Marion County's first courthouse. This photograph, taken about 1880, also shows the Mountain City House, a well-known hotel, on the right. Both of these buildings were demolished in 1897 to make room for the new Marion County Courthouse, which is still in use today.

This building was formerly used as a post office and was erected on Monroe Street in Fairmont to succeed the original post office on Jefferson Street in Fairmont. Eventually, the postal authorities decided that more room was needed for the post office and another move was authorized. After some negotiations, the ex-post office building became home to the Marion County Public Library. The library continues to operate at this location.

View of United States Post Office and Courthouse, Fairmont, W. Va. — 4

Here is an artist's drawing of the proposed post office and federal building to be located at Fairmont Avenue and Second Street in Fairmont. The post office moved its operations here in the mid-1930s and stayed at this location until the mid-1980s, when a new building was erected at the corner of Madison and Jackson Streets. One complaint against the Fairmont Avenue site had been that it had inadequate parking; therefore, a large parking area was secured along Madison Street for the new building.

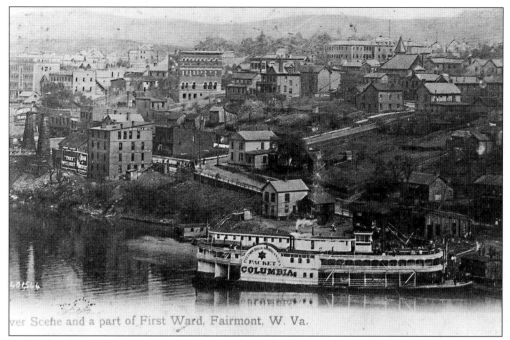

ver Scene and a part of First Ward, Fairmont, W. Va.

In the days before the B&O Railroad came through the area in 1852, transportation had to be handled by stagecoach or by an individual's own horse and carriage or riding horse. It was considered a great luxury to be able to ride on a steamboat up and down the river on those occasions that a steamboat captain would attempt to come this far upstream. Even after the railroad made travel much more convenient, local people were still thrilled to be able to ride a steamboat, such as this one, which made the trip to Fairmont safely in a period of high water.

There seems to be no better way to get away from the cares of the world than to go to a secluded spot to enjoy some tranquil fishing. Marion County has a number of special spots where the angler can get away from the hustle and bustle of ordinary life. These two gentlemen may not really care whether or not they reel in many fish, but they certainly can relax.

You may be able to "dress up" young boys but you will have a hard time keeping them neat and tidy—especially when there is a chance to go fishing! These boys' mother would be horrified if she were able to see them as they appear here, with their coats laid over a fence and their shoes removed. We hope that these boys did not fall into the water or get too dirty before they got home!

Like father, like son, and like grandson. In this 1901 photograph, Dr. Leniel L. Yost, a prominent Fairmont surgeon, poses with his son Ernest Lee Yost, who later became a surgeon as well. Dr. L.L. Yost was the son of Dr. Fielding H. Yost, a Confederate Army surgeon.

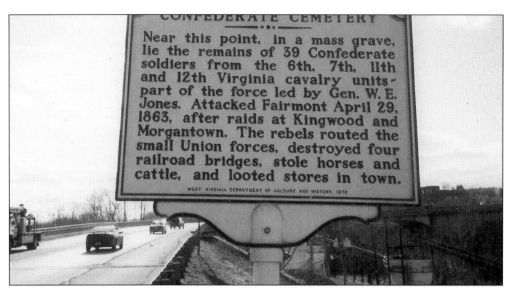

CONFEDERATE CEMETERY

Near this point, in a mass grave, lie the remains of 39 Confederate soldiers from the 6th, 7th, 11th and 12th Virginia cavalry units—part of the force led by Gen. W. E. Jones. Attacked Fairmont April 29, 1863, after raids at Kingwood and Morgantown. The rebels routed the small Union forces, destroyed four railroad bridges, stole horses and cattle, and looted stores in town.

WEST VIRGINIA DEPARTMENT OF CULTURE AND HISTORY. 1978

A plaque marks the general location of a believed Confederate cemetery near the David Morgan Bridge on the east side of the Monongahela River. Gen. W.E. Jones led a Confederate attack on Fairmont on April 29, 1863 with the intent of destroying railroad bridges and rounding up all the horses and cattle he could manage. Jones's forces destroyed the large railroad bridge just south of Fairmont and stole a number of horses and other livestock. Considerable controversy surrounds the validity of this cemetery and its location.

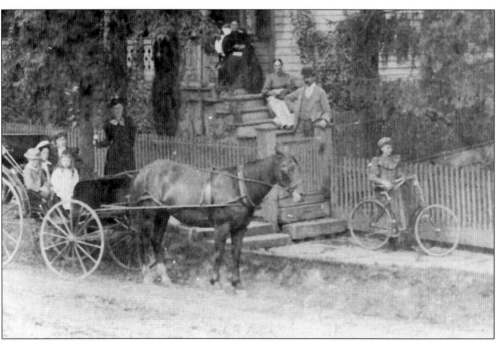

Two methods of transportation are portrayed in this late 1800s photograph of a Marion County family. The young lady, apparently having decided not to ride in the buggy, is ready to set out on her bicycle. The well-dressed children in the buggy wait for the driver to take the reins. The people on the porch and steps seem content to stay home and relax instead of going on a trip.